PHOTOSECRETS
HAWAI'I

WHERE TO TAKE PICTURES

BY
ANDREW HUDSON

*"A good photograph
is knowing where to stand."*
— Ansel Adams

A GREAT TRAVEL photograph, like a great news photograph, requires you to be in the right place at the right time to capture that special moment. Professional photographers have a short-hand phrase for this: "F8 and be there."

There are countless books that can help you with photographic technique, the "F8" portion of that equation. But until now, there's been little help for the other, more critical portion of that equation, the "be there" part.

To find the right spot, you had to expend lots of time and shoe leather to research the area, walk around, track down every potential viewpoint, see what works, and essentially re-invent the wheel.

In my career as a professional travel photographer, well over half my time on location is spent seeking out the good angles. Andrew Hudson's PhotoSecrets does all that legwork for you, so you can spend your time photographing instead of wandering about. It's like having a professional location scout in your camera bag. I wish I had one of these books for every city I photograph on assignment.

PhotoSecrets can help you capture the most beautiful sights with a minimum of hassle and a maximum of enjoyment. So grab your camera, find your favorite PhotoSecrets spots, and "be there!"

Bob Krist has photographed assignments for *National Geographic, National Geographic Traveler, Travel/Holiday, Smithsonian,* and *Islands.* He won "Travel photographer of the Year" from the Society of American Travel Writers in 1994, 2007, and 2008 and today shoots video as a Sony Artisan Of Imagery.

For *National Geographic,* Bob has led round-the-world tours and a traveling lecture series. His book *In Tuscany* with Frances Mayes spent a month on *The New York Times'* bestseller list and his how-to book *Spirit of Place* was hailed by *American Photographer* magazine as "the best book about travel photography."

After training at the American Conservatory Theater, Bob was a theater actor in Europe and a newspaper photographer in his native New Jersey. The parents of three sons, Bob and his wife Peggy live in New Hope, Pennsylvania.

Contents

📍 Hawai'i

Hawai'i is a U.S. state in the Pacific Ocean, encompassing a group of volcanic islands. The four most traveled islands are O'ahu (with the city of Honolulu), Maui, Kaua'i and Hawai'i (known as the "Big Island").

📍 Oʻahu > Honolulu

Honolulu is the state capital and the most populous city of Hawaiʻi, home to 2/3 of the state's population in the metro area. Most visitors to Hawaiʻi arrive in Honolulu to enjoy the white-sand, palm-tree-lined beaches of Waikīkī, on the southeast coast of Oʻahu.

📍 O'ahu

O'ahu is the most populated and most visited island of Hawai'i. Beside the city of Honolulu, your camera will appreciate the views from Koko Crater, the Jurassic Park scenery of the windward cliffs, and the memorials at Pearl Harbor.

📍 Maui

Maui is the second-largest of the Hawaiian Islands, and, for visitors, the second-most popular. Explore tropical beaches, exotic waterfalls and a volcano crater.

♀ Kaua‘i

Kaua‘i is geologically the oldest of the main Hawaiian Islands. Known as the "Garden Isle", Kaua‘i is home to the wettest non-monsoon spot on Earth, producing deep, eroded valleys, and towering scenic waterfalls.

📍 Hawaiʻi Island

Hawaiʻi is the "Big Island", the largest and newest of the Hawaiian Islands. In the southeast is an active volcano, occasionally erupting with lava and making the island larger.

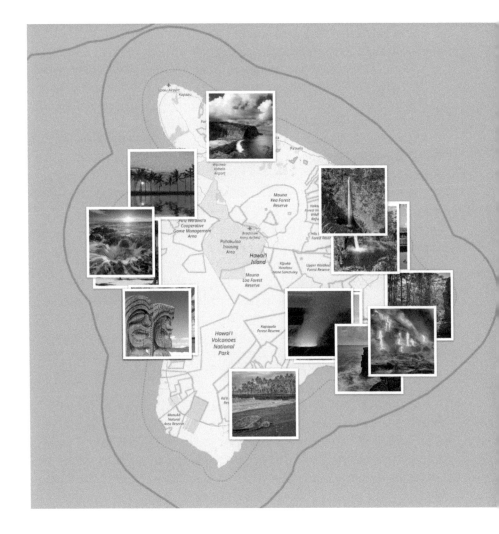

ℹ️ Introduction

Hawai'i beckons your camera with lush, Jurassic Park-style scenery with exotic waterfalls and tropical beaches.

The U.S. state of Hawai'i is the 50th and most recent state, joining in 1959; the only state located in Oceania, and the only one composed entirely of islands.

There are over 100 islands in the Hawaiian archipelago, in an almost straight line extending around 1,500 miles (2,400 kilometers). They are the exposed peaks of a great undersea mountain range known as the Hawaiian–Emperor seamount chain, formed by volcanic activity over a hotspot in the Earth's mantle. The most populated four islands are O'ahu, Maui, Kaua'i and Hawai'i (the "Big Island").

The islands were first settled by Polynesians, most likely from Tahiti, sometime between 124 and 1120 BCE. Hawaiian civilization was isolated from the rest of the world for at least 500 years.

British explorer Captain James Cook was the first recorded western visitor, in 1778. Within five years, European military technology helped Kamehameha I conquer and unify the islands for the first time, establishing the Kingdom of Hawai'i.

Americans set up plantations to grow sugar, which required substantial labor and drew immigrants from Japan, China and the Philippines. The government of Japan organized and gave special protection to its people, who comprised about 25 percent of the Hawaiian population by 1896. The native population fared less well, declining from 300,000 in the 1770s to 24,000 in 1920, mainly from smallpox and other European diseases. The U.S. annexed Hawai'i in 1898, making it a U.S. territory.

In 1941, the U.S. Pacific Fleet in Pearl Harbor was attacked by the Imperial Japanese Navy, killing almost 2,500 people and sinking the main American battleship fleet. Six months later, Pearl Harbor prepared three aircraft carriers to win the Battle of Midway (part of the Hawaiian archipelago), widely considered a turning point in the Pacific War.

Today, over 9 million people visit Hawai'i each year.

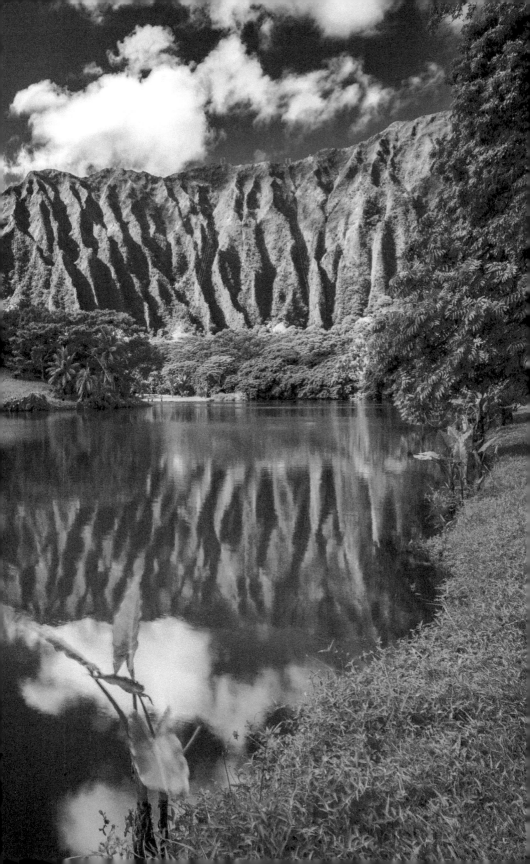

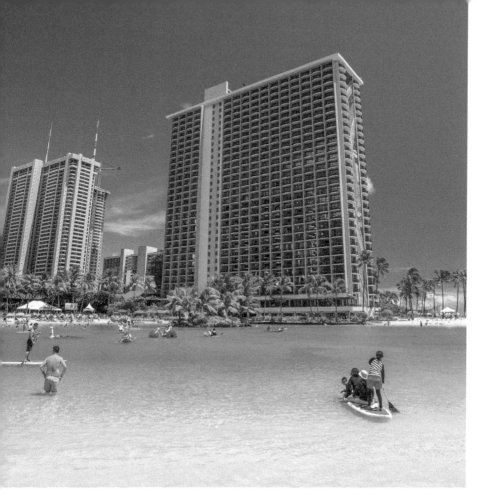

The **Hilton Hawaiian Village** is the largest hotel in Hawai'i, with 2,860 rooms, and the largest in the U.S. outside of Las Vegas. The property anchors the north end of the beach in Waikīkī — the tourist district of Honolulu on the island of O'ahu — and has its own lagoon.

✉ **Addr:**	2005 Kalia Rd, Honolulu HI 96815	♀ **Where:**	21.282896 -157.839557
❓ **What:**	Hotel	◑ **When:**	Afternoon
👁 **Look:**	Southeast	W **Wik:**	Hilton_Hawaiian_Village

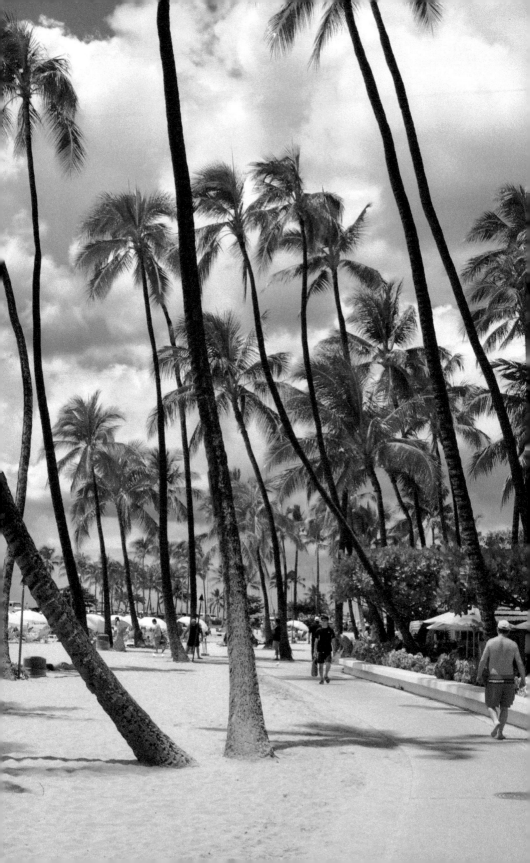

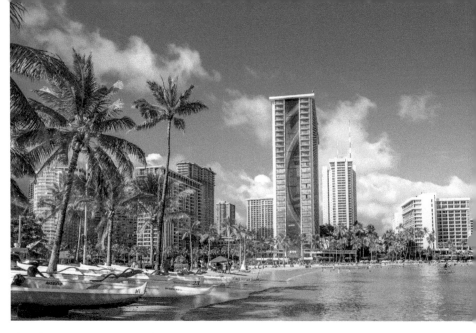

The Hilton's Rainbow Tower features the world's largest ceramic tile mosaic.

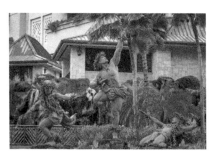 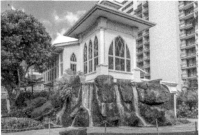

Three hula dancers at the entrance and the Akalā Chapel over a waterfall.

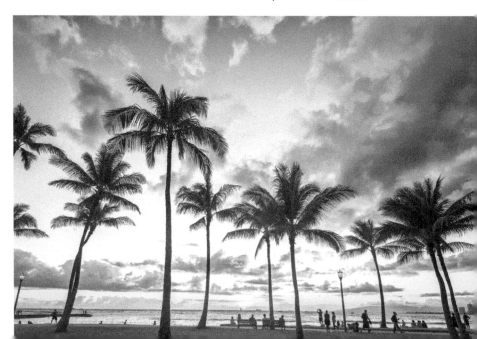

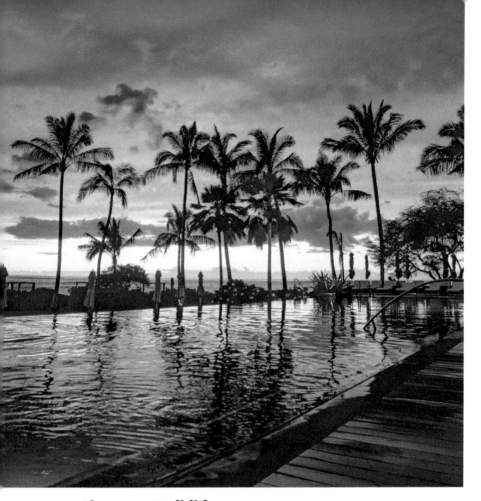

The **Sheraton Waikiki** is the second-largest hotel in Hawai'i and offers the photogenic Infinity Edge Pool. Looking west you can catch the sunset (above) and looking south (next page) you can see Koko Crater, an ancient volcano.

✉ **Addr:**	2255 Kalakaua Ave, Honolulu HI 96815	⚲ **Where:**	21.276998 -157.830572
❓ **What:**	Group	☽ **When:**	Anytime
👁 **Look:**	West	↔ **Far:**	30 m (110 feet)

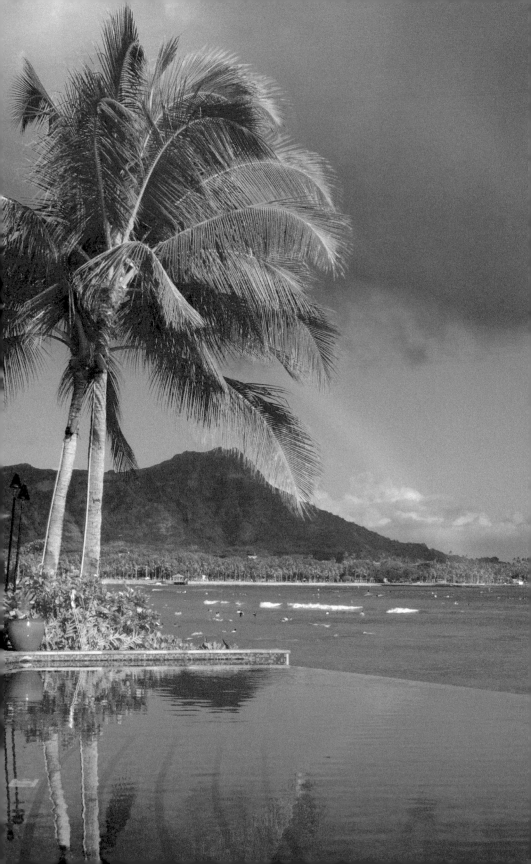

Rumfire

Sherraton
Waikiki

Rumfire

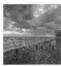

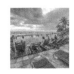

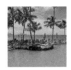

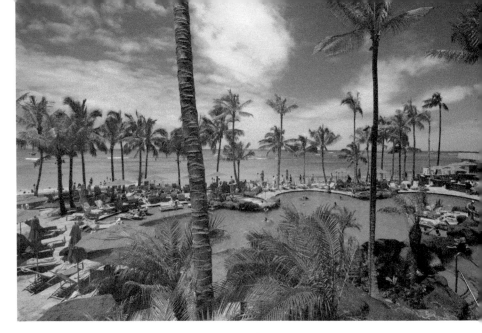

The Helumoa Pool, photographed from the top of the water slide.

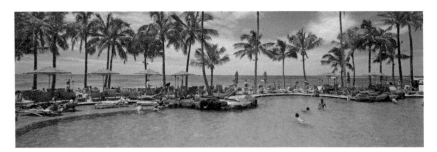

Relaxing at sunset, looking west from the Infinity Edge Pool.

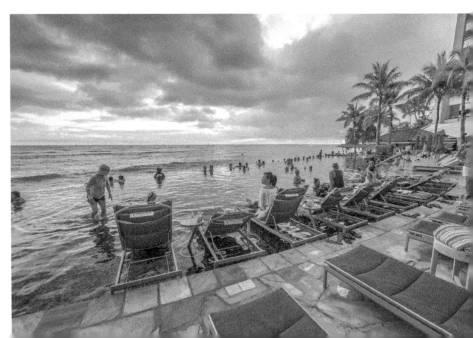

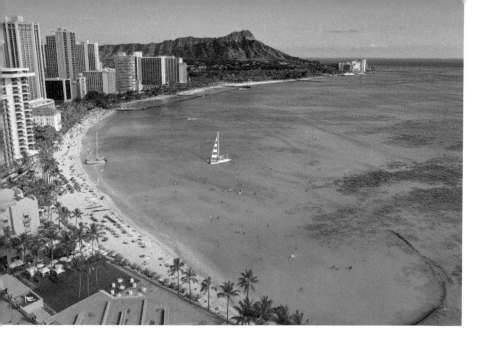

The **Leahi Club Lounge** on the 30th floor of the Sheraton Waikiki has the best high view of Waikīkī Beach and Diamond Head. Unfortunately, the lounge is for hotel guests only — free for people staying in premium rooms, and a per-day fee for standard rooms.

To photograph through the windows without getting reflections, cover your camera and head with dark clothing, or use black card with a hole for your lens. This is particularly important for dusk shots, when the light in the room is as bright as the light outside.

Looking south you can see Waikīkī Beach, Kūhiō Beach and Queen's Beach as they arc around to Koko Crater on the headlands.

✉ **Addr:**	2255 Kalakaua Ave, Honolulu HI 96815	♀ **Where:**	21.277053 -157.830182
❓ **What:**	Observation deck	☽ **When:**	Afternoon
👁 **Look:**	Southeast	W **Wik:**	Sheraton_Waikīkī_Hotel

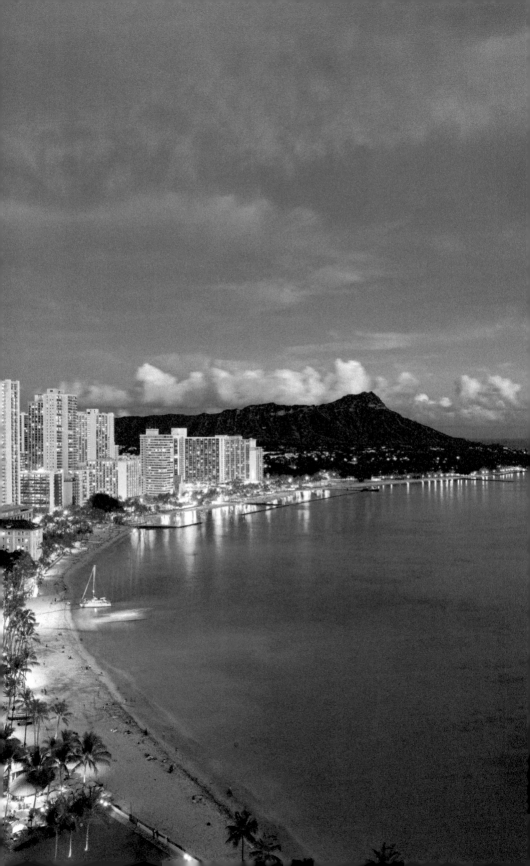

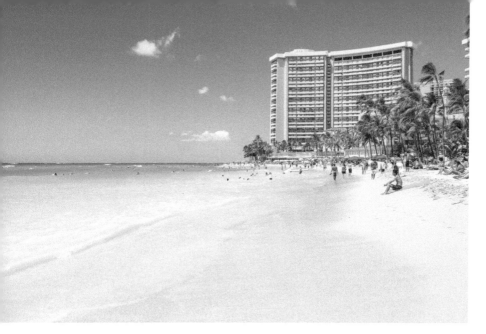

Waikīkī Beach is a paradise of white sand and palm trees stretching from the Sheraton to Kūhiō Beach Hula Mound. These photos from the center are looking north (above), south (below), and west with atmospheric surfboards.

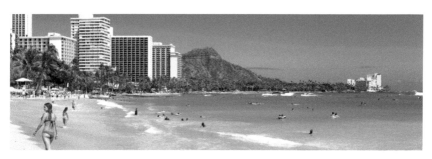

✉ **Addr:**	Kalakaua Ave, Honolulu HI 96815	♀ **Where:**	21.2760786 -157.8271162	
❓ **What:**	Beach	☽ **When:**	Morning	
👁 **Look:**	West-northwest	W **Wik:**	Waikīkī	

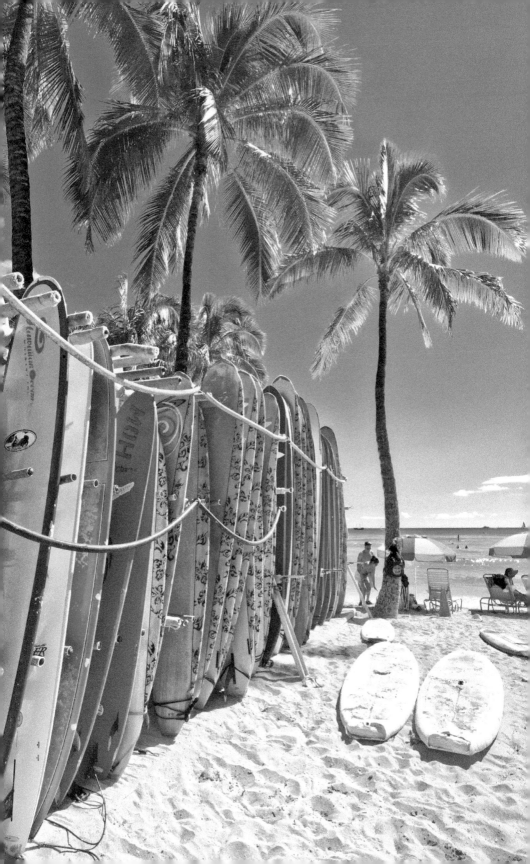

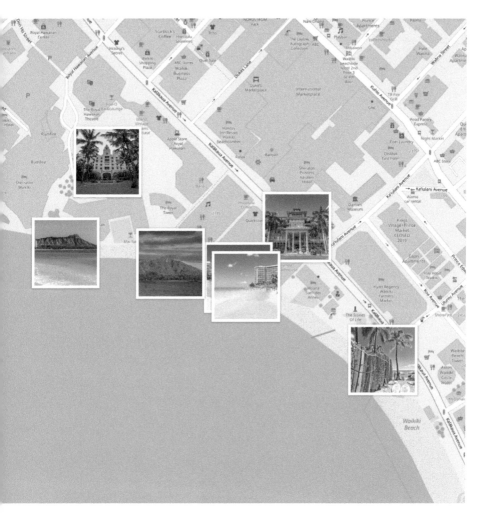

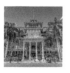

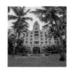

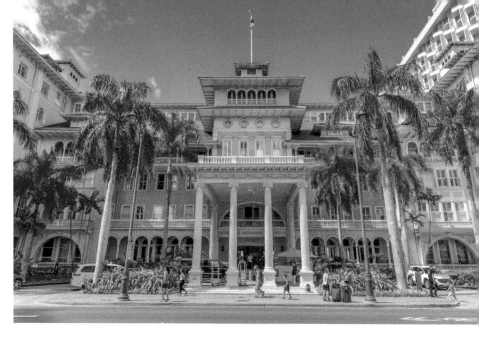

Two historic beachfront hotels are the **Moana Surfrider** (above), opened in 1901 as Waikīkī's first hotel, and the **Royal Hawaiian** (below), opened in 1927.

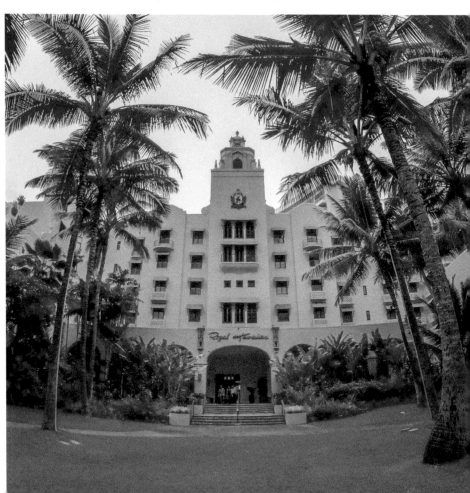

Duke Paoa Kahanamoku is a statue of how I look in shorts. The famous Native Hawaiian (1890 – 1968) was a five-time Olympic medalist in swimming and popularized the ancient Hawaiian sport of surfing. He introduced surfing to Southern California in 1912 and to Australia in 1914.

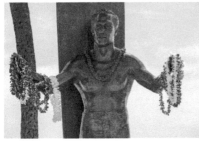

In 1925, Kahanamoku saved the lives of eight men from a capsized fishing vessel by using his surfboard, inspiring U.S. lifeguards to use surfboards in their water rescues.

✉ **Addr:**	Kalakaua Ave, Honolulu HI 96815	♀ **Where:**	21.275608 -157.825261
? **What:**	Statue	☾ **When:**	Morning
👁 **Look:**	South	W **Wik:**	Duke_Kahanamoku

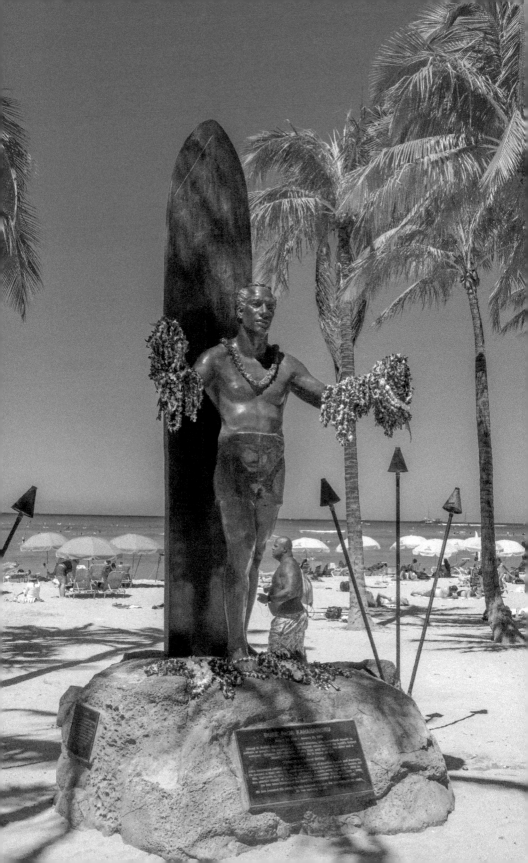

Kūhiō Beach is the central and most popular part of the Waikīkī Beach area. Bring your camera to the Kūhiō Beach Torch Lighting and Hula Show which provides free photogenic entertainment every Tuesday, Thursday and Saturday, from 6:30pm to 7:30pm (weather-permitting, Nov–Jan 6pm–7pm).

Northeast of the Kūhiō Beach Hula Mound, at Kalakaua Avenue, is an interesting and historic banyan tree. There is another mound 670 feet (200 m) south from which the next picture is taken.

✉ **Addr:**	2450 Kalakaua Ave, Honolulu HI 96815	♀ **Where:**	21.2750531 -157.8249188	
❓ **What:**	Beach	☾ **When:**	Anytime	
👁 **Look:**	South-southwest	↔ **Far:**	21 m (69 feet)	

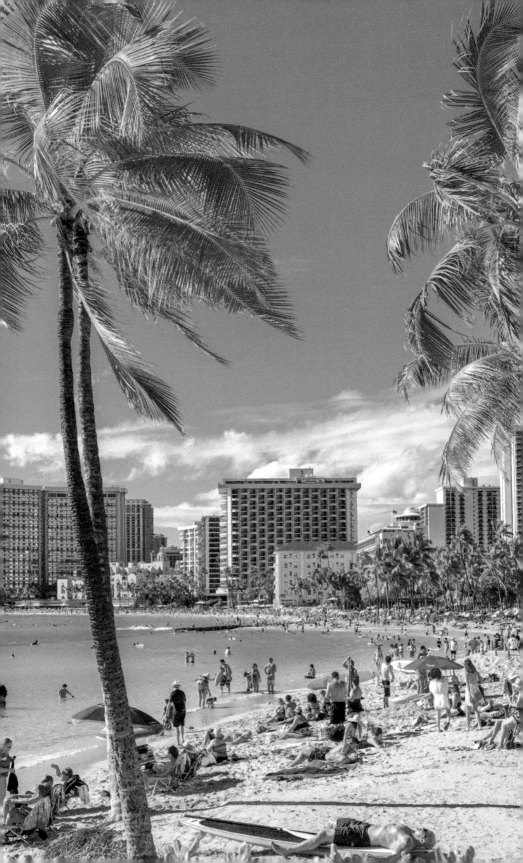

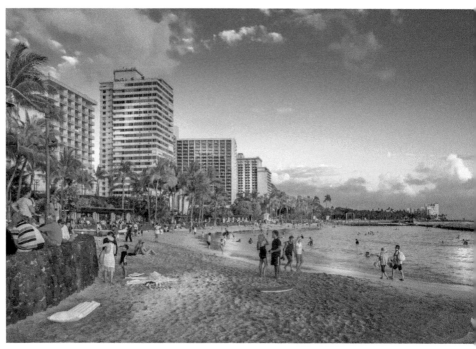

To capture the fire streaks at night, use a tripod or other camera support and a slower shutter speed around 1/8s. Switch your flash off to use only natural light, or fill in a touch of light with a slow-sync, rear-curtain "fill" flash at around -1 EV.

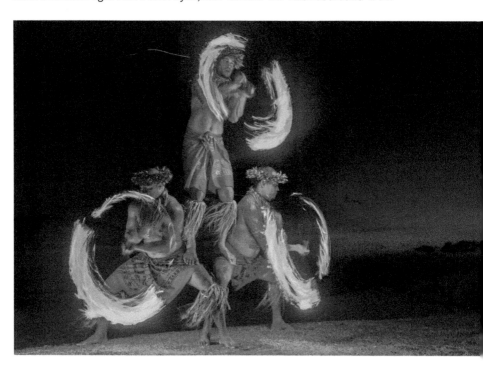

Waikīkī Wall is a publicly-accessible jetty (or "groin") that extends into the ocean to protect the beach. The wide wall provides good views over Kūhiō Beach to the north and Queen's Beach to the south.

At the entrance by Kalakaua Avenue is "Mākua and Kila," a sculpture of a young surfer and a monk seal from a children's book.

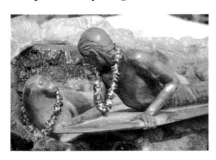
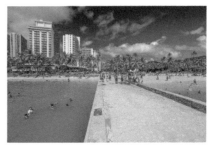

✉ **Addr:**	2605 Kalakaua Ave, Honolulu HI 96815	♀ **Where:**	21.271267 -157.823281
❓ **What:**	Jetty	☽ **When:**	Morning
👁 **Look:**	West-southwest	↔ **Far:**	50 m (160 feet)

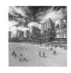 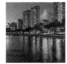

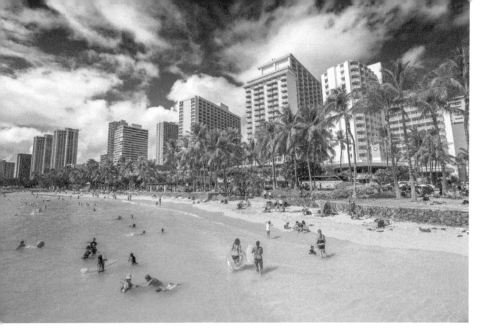

Take photos seemingly from above the ocean by standing on the Waikīkī Wall.

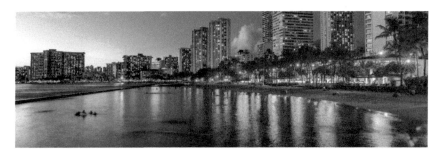

Looking north to Kūhiō Beach (above) and south to Queen's Beach.

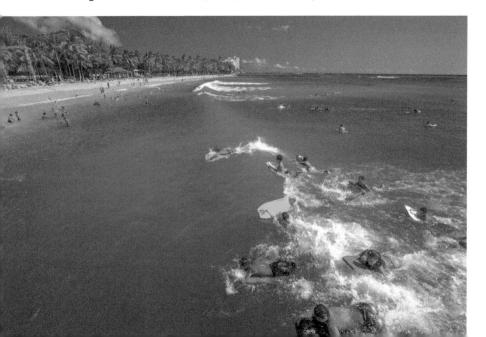

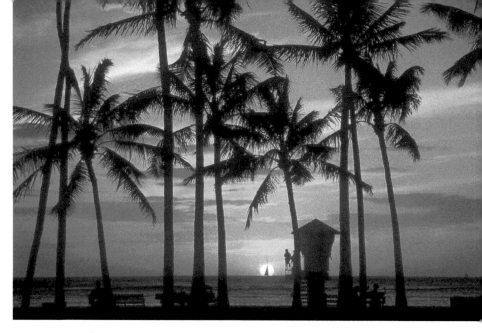

Sans Souci Park lies south of the main Waikīkī Beach area, and includes Queen's Beach, Kapiolani Beach and Kaimana Beach (above), which faces west to the setting sun. This shot uses the palm trees and a lifeguard tower as silhouettes.

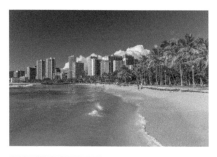
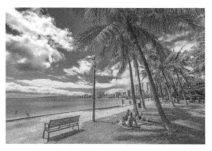

✉ **Addr:**	2700 Kalakaua Ave, Honolulu HI 96815	♀ **Where:**	21.263591 -157.821425
❓ **What:**	Park	☽ **When:**	Morning
👁 **Look:**	West	↔ **Far:**	70 m (240 feet)

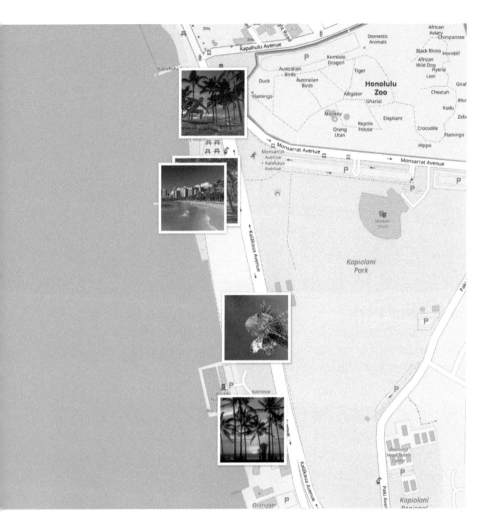

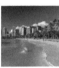

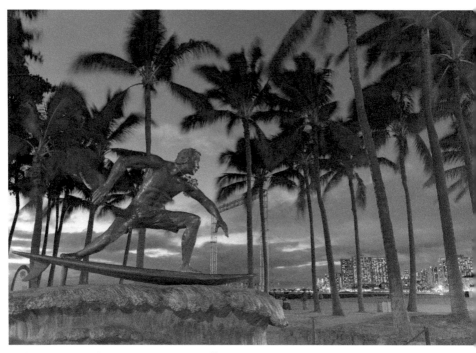

At the north end of Sans Souci Park is **Surfer on a Wave** (2003) by Robert Pashby (above) and the **Waikīkī Aquarium** (below). Waikīkī Aquarium was built next to a living coral reef in 1904 and is the third oldest public aquarium in the United States.

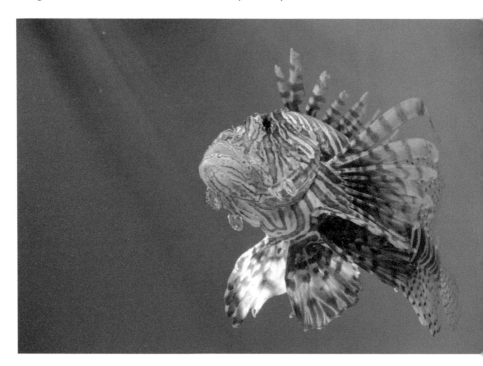

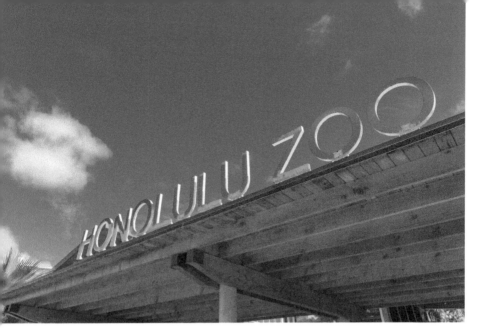

Honolulu Zoo is the best zoo for over 2,300 miles, and not just because it is the only zoo for 2,300 miles. Opened in 1947, the 42-acre (17 ha) zoo has more than 1,200 animals, including Galápagos tortoises, Sumatran orangutans and African lions.

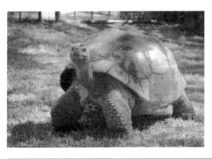
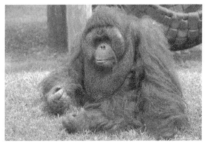

✉ **Addr:**	151 Kapahulu Ave, Honolulu HI 96815	♥ **Where:**	21.271084 -157.821662	
❓ **What:**	Zoo	◑ **When:**	Afternoon	
👁 **Look:**	East-northeast	W **Wik:**	Honolulu_Zoo	

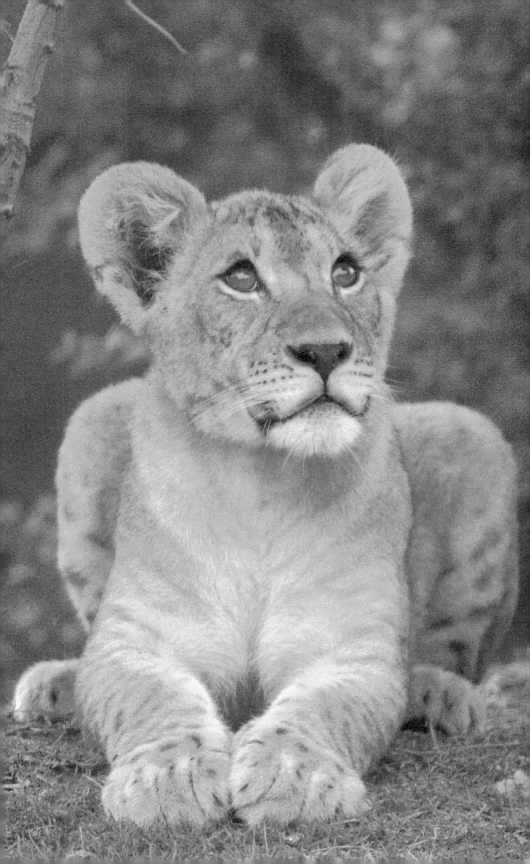

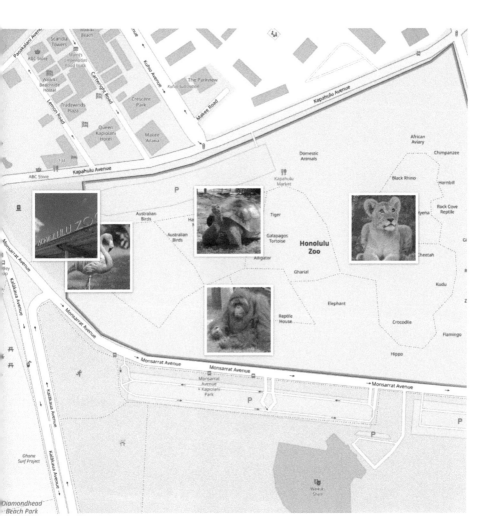

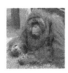

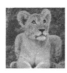

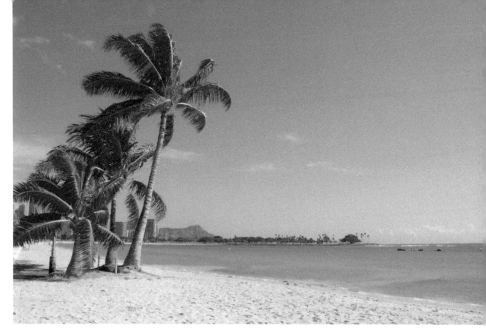

Ala Moana Beach Park is a half-mile-long, gold-sand beach (above) with calm water protected by a reef. Located northwest of Waikīkī Beach, the park has a landscaped lagoon in the northeast corner with a row of picturesque palm trees on its south shore (below).

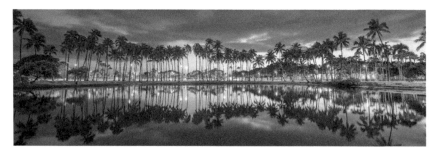

✉ **Addr:**	1201 Ala Moana Blvd, Honolulu HI 96814	♥ **Where:**	21.290936 -157.854124	
❓ **What:**	Beach	☽ **When:**	Afternoon	
👁 **Look:**	Southeast	W **Wik:**	Ala_Moana_Beach_Park	

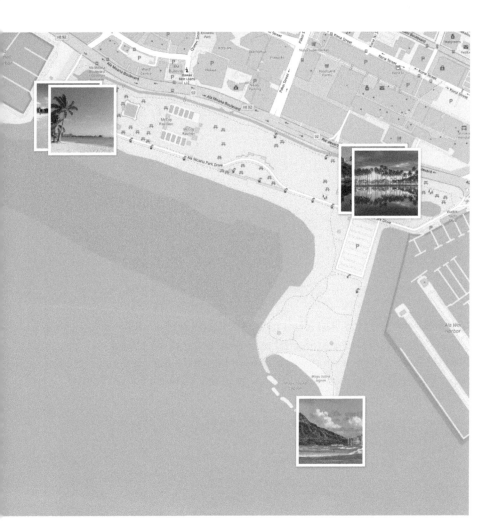

 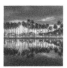 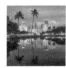

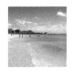 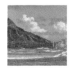

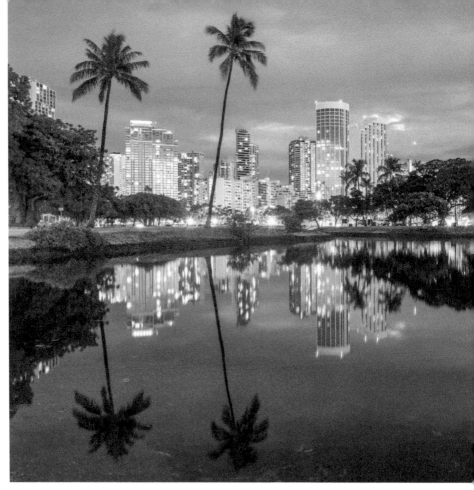

Ala Moana Beach Park has views of Downtown Honolulu (above, from the park's lagoon) and Koko Crater (below, from Magic Island).

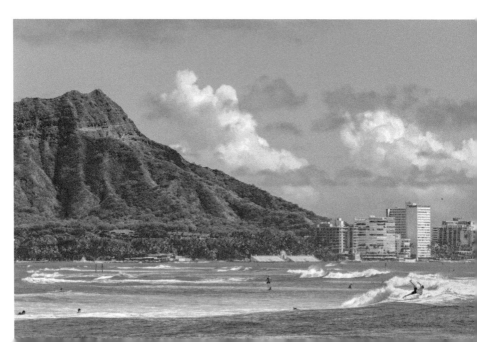

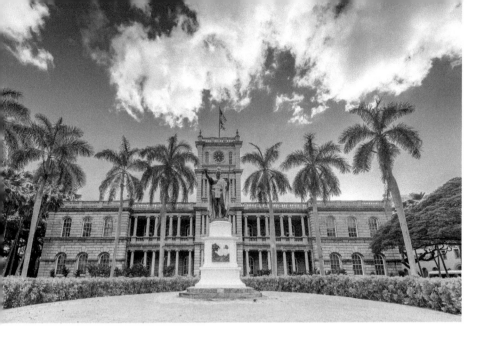

Ali'iōlani Hale

Ali'iōlani Hale (House of Heavenly Kings) was designed as the royal palace for King Kamehameha V, but used from 1874 to 1893 as the seat of government of the Kingdom of Hawai'i. Today, the building houses the Hawai'i State Supreme Court.

In the courtyard is the famed gold-leaf statue of Kamehameha the Great, the founding monarch of the Kingdom of Hawai'i.

Commissioned in 1878, there are two other casts of this statue, one at the king's birthplace in Kapa'au on the island of Hawai'i, and another at the United States Capitol Visitor Center in Washington, D.C.

✉ Addr:	417 S King St, Honolulu HI 96813	♀ Where:	21.305873 -157.85942
❓ What:	Courthouse	◐ When:	Morning
👁 Look:	Southwest	W Wik:	Ali'iōlani_Hale

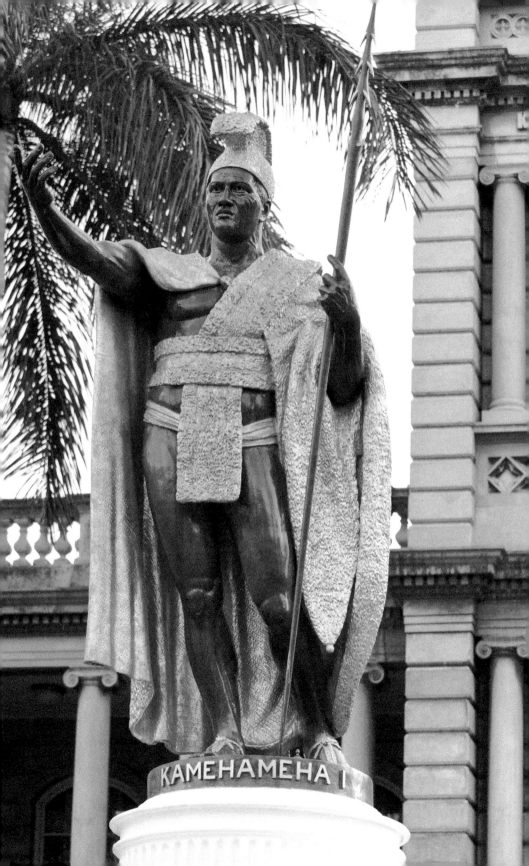

KAMEHAMEHA I

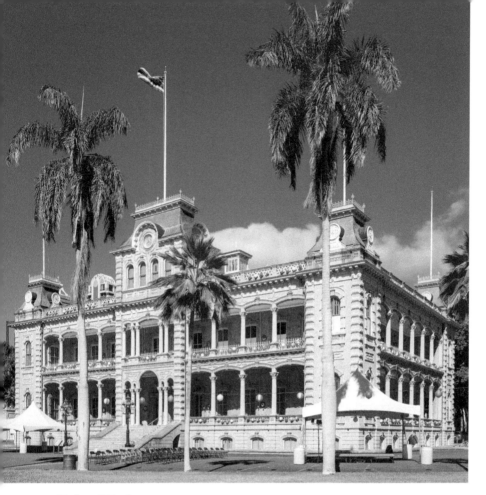

ʻIolani Palace is the only royal palace on U.S. soil. Built in in a unique architectural style seen nowhere else in the world, the palace was the royal residence from 1882 to 1893, then the capitol building until 1969.

✉ **Addr:**	364 S King St, Honolulu HI 96813	📍 **Where:**	21.3061151 -157.859228
❓ **What:**	Area	◑ **When:**	Anytime
👁 **Look:**	North-northeast	W **Wik:**	"ʻIolani_Palace

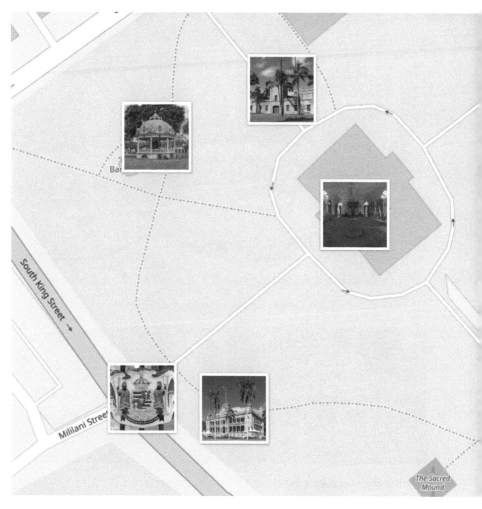

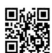
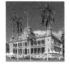
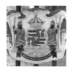
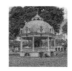

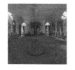

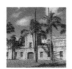

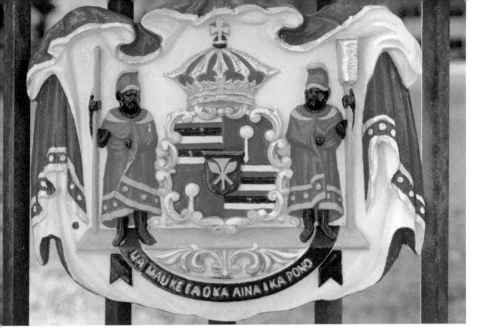

The royal seal, the bandstand (coronation pavilion), and the throne room.

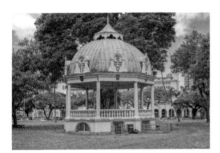
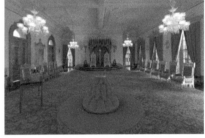

ʻIolani Barracks was built in 1870 and housed the Royal Guard.

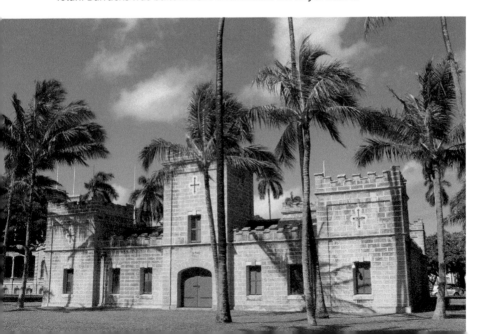

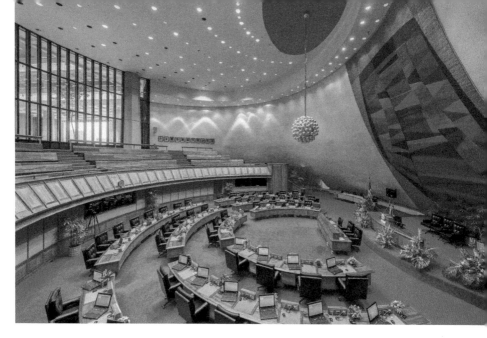

The **Hawai'i State Capitol** is the official statehouse of Hawai'i. The building houses the Governor of Hawai'i, the Hawai'i State Legislature, and related offices. It opened on March 15, 1969, replacing the former statehouse, the 'Iolani Palace.

The style is an American adaptation of the Bauhaus style termed "Hawaiian international" with symbols of Hawai'i, including legislative chambers shaped like volcano cones (above) and an open atrium honoring the sky as Hawai'i's capitol dome (next).

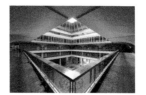

✉ **Addr:**	415 S Beretania St, Honolulu HI 96813	♀ **Where:**	21.307462 -157.857273
❷ **What:**	Statehouse	◑ **When:**	Morning
👁 **Look:**	South	W **Wik:**	Hawai'i_State_Capitol

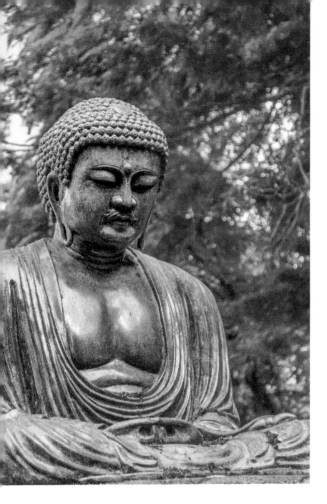

Daibutsu is a small replica of the Great Buddha (Daibutsu) in Kamakura, Japan to commemorate 100 years of Japanese immigration to Hawai'i. This Buddha sits in quiet contemplation at Foster Botanical Garden, built in 1853 and the oldest botanical garden in Hawai'i.

The garden, in a highly urban area, is the inspiration for a line in Joni Mitchell's 1970 folk song "Big Yellow Taxi": "Took all the trees, put 'em in a tree museum / Then charge people a dollar and a half just to see 'em."

✉ **Addr:**	180 N Vineyard Blvd, Honolulu HI 96817	♀ **Where:**	21.316103 -157.857952
❷ **What:**	Statue	☽ **When:**	Morning
👁 **Look:**	West-northwest	W **Wik:**	K%C5%8Dtoku-in#Daibutsu_(Great_Buddha)

Elvis Aloha from Hawai'i is a life-size bronze statue of the "King of Rock and Roll." The statue commemorates the world's first satellite TV concert with a single performer in 1973. Aired in over 40 countries, the concert was broadcast from the building behind, then known as the Honolulu International Center, now the Neal Blaisdell Center.

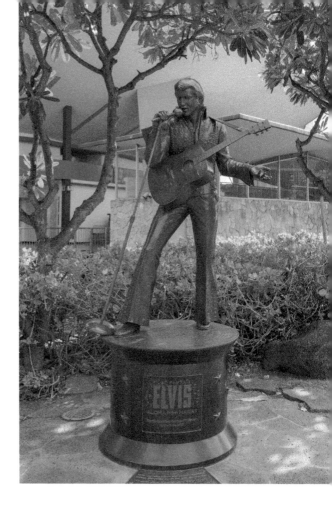

✉ **Addr:**	Neal S. Blaisdell Arena, Honolulu HI 96814	♀ **Where:**	21.299531 -157.851664
❷ **What:**	Statue	◑ **When:**	Afternoon
👁 **Look:**	Southeast	Ⓦ **Wik:**	https://en.wikipedia.org/wiki/Aloha_from_Hawai'i_Via_Satellite

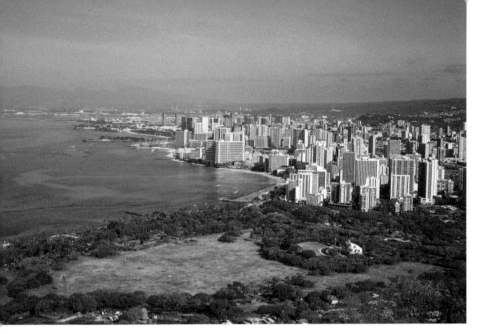

Diamond Head is a volcanic tuff cone with views of Honolulu and Diamond Head Light. Known to Hawaiians as Lēʻahi, the English name was given by British sailors in the 19th century, who mistook calcite crystals on the adjacent beach for diamonds.

You can hike to the top for magnificent views.

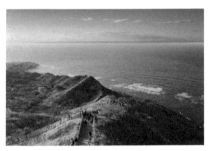
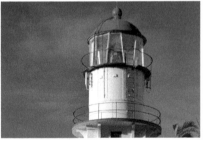

✉ **Addr:**	Diamond Head, Honolulu HI 96815	♀ **Where:**	21.259674 -157.8117	
❓ **What:**	Crater	◐ **When:**	Morning	
👁 **Look:**	North-northwest	W **Wik:**	Diamond_Head,_Hawaiʻi	

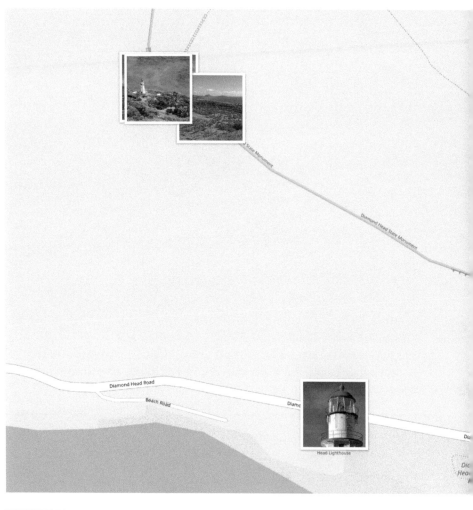

Diamond Head State Monument

Diamond Head Road

Beach Road

Diamo

Head Lighthouse

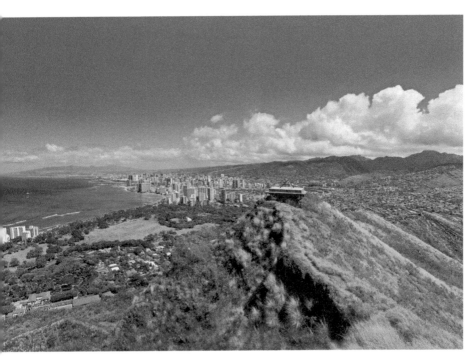

A lookout at the top of Diamond Head has views all around. Above: the view of Honolulu and a bunker (pill box, built in 1915) of Fort Ruger, established in 1906. Below: The view of Diamond Head Lighthouse, built in 1917.

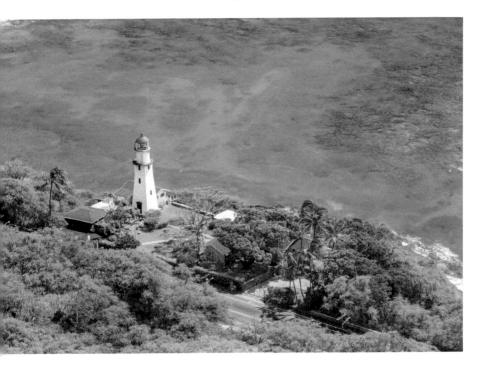

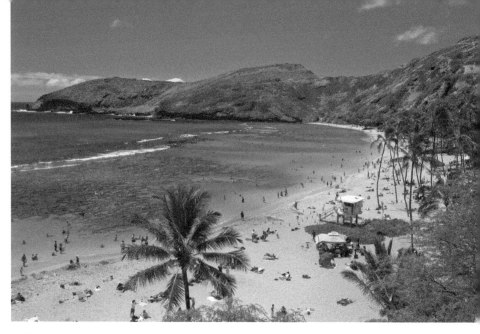

Hānauma Bay is a marine bay inside a volcanic cove. From a hike above the bay, you can see the outline of the tuff ring (below).

Hānauma is a Marine Life Conservation District, the first of several established in the State of Hawai'i. Lucky snorkelers can see green sea turtles here, known in Hawaiian as *Honu*.

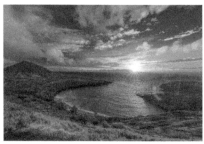

The bay is closed to tourists on Tuesdays in order to allow the fish a day of feeding without interruption by swimmers.

✉ **Addr:**	Hānauma Bay, Koko Head HI 96825	♀ **Where:**	21.272793 -157.696184
❷ **What:**	Bay	◑ **When:**	Anytime
👁 **Look:**	South-southwest	Ⓦ **Wik:**	Hānauma_Bay

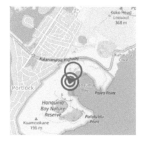

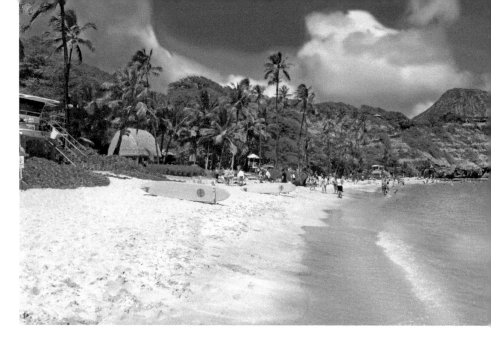

Views of and around Hānauma Beach.

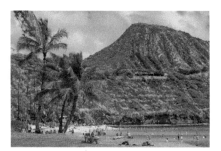
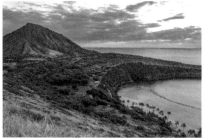

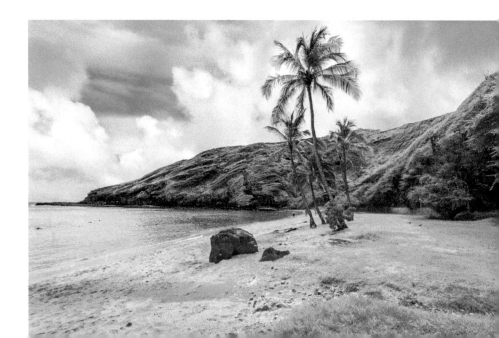

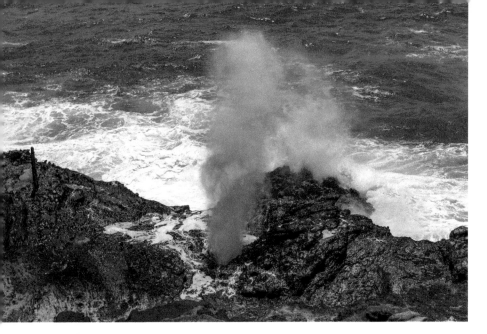

Hālona offers a blowhole and a movie-famous beach.

When the tide is high and the winds are strong, Hālona Blowhole erupts like a geyser, shooting sea spray up to thirty feet high. Lava tubes in the ocean funnel the waves through a narrow opening in the cliff.

From Here to Eternity (1953) was filmed at Hālona Cove. The iconic beach scene saw Deborah Kerr and Burt Lancaster swept up in love and surf.

✉ **Addr:**	8483 HI-72, Honolulu HI 96825	♀ **Where:**	21.282266 -157.676768	
❓ **What:**	Cove	◑ **When:**	Afternoon	
👁 **Look:**	East	W **Wik:**	Hālona_Blowhole	

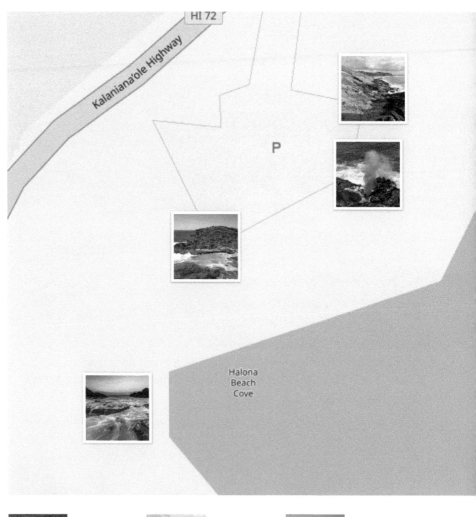

HI 72

Kalaniana'ole Highway

P

Halona
Beach
Cove

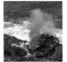 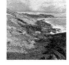 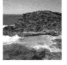

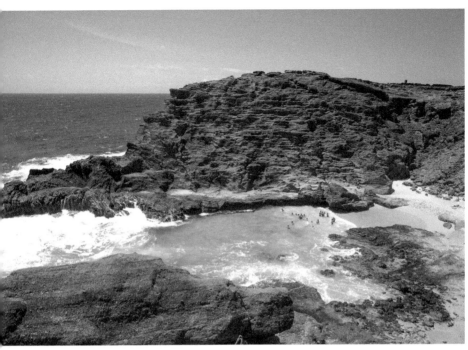

Hālona Blowhole and Cove can be photographed from the parking lot.
Below is a long-exposure sunset shot. Get low and use a tripod for this cool effect.

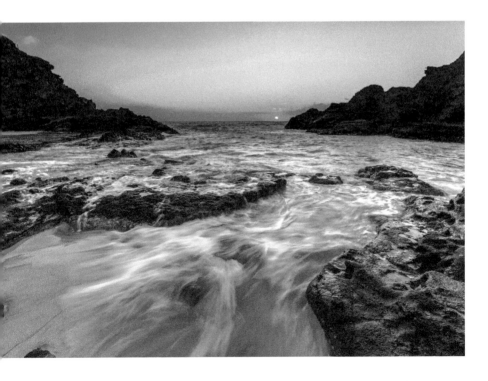

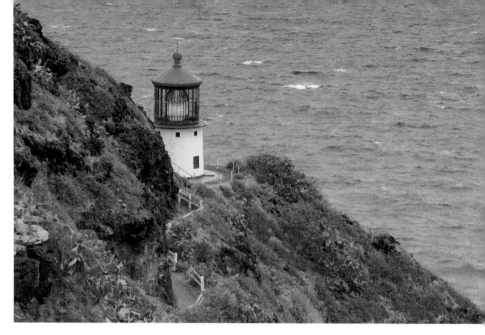

Makapuʻu is the extreme eastern end of the Island of Oʻahu. There is a scenic lighthouse which can be photographed from two lookouts along a paved 1.2 mile (2 km) hiking trail.

Built in 1909, the lighthouse has the largest lens of any lighthouse in the United States — twelve feet tall with over a thousand prisms.

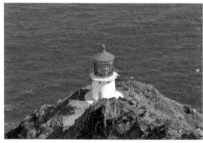

Makapuʻu Point is the eastern-most point of Oʻahu and the landfall for all sea traffic coming to Honolulu from the American west coast, so a powerful lighthouse was needed at this strategic location.

✉ **Addr:**	Hawaiʻi Kai, Waimanalo HI 96795	♀ **Where:**	21.308539 -157.650756
❷ **What:**	Area	◑ **When:**	Anytime
👁 **Look:**	Northeast	W **Wik:**	Makapu%CA%BBu

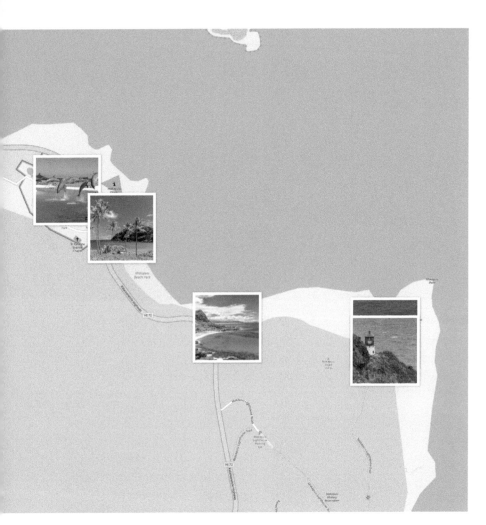

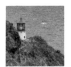

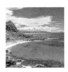

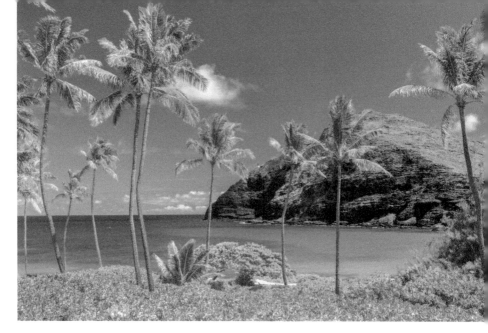

Makapuʻu Beach from the parking lot (above) and from Makapuʻu Point (below).

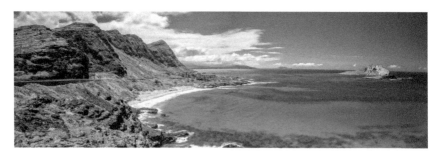

Sea Life Park Hawaiʻi features dolphin shows and sea turtle feeding.

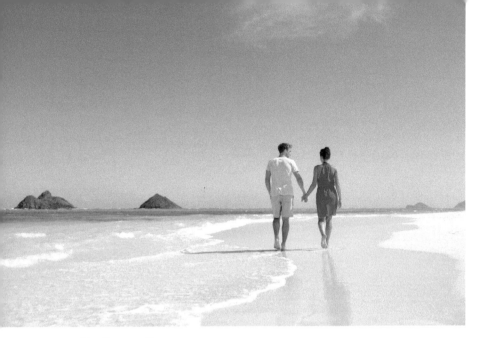

Lanikai Beach is consistently ranked among the best beaches in the world. It's also great for photo shoots due to the soft powdery clean white sand and two islands in the background called the Nā Mokulua or "mokes" which provide distant focal points.

There is no public parking nearby so hike in from Kailua.

✉ **Addr:**	Lanikai, Kailua HI 96734I	♀ **Where:**	21.3932173 -157.7154045	
❓ **What:**	Beach	◑ **When:**	Afternoon	
👁 **Look:**	East-southeast	W **Wik:**	Lanikai_Beach	

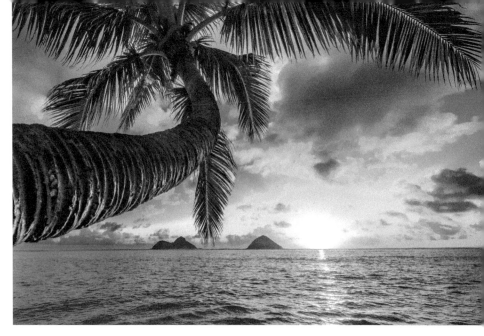

By the entrance is a photogenic palm tree growing toward the setting sun.

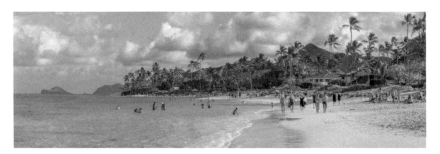

The Pillbox Hike climbs a ridge above the beach with several pillbox lookouts.

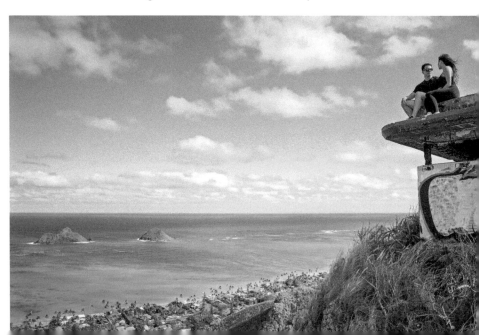

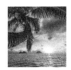
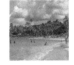

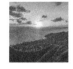

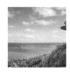

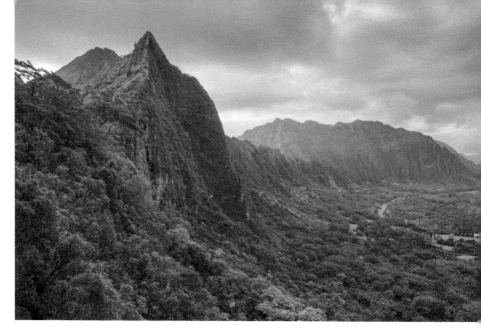

Nu'uanu Pali Lookout has sweeping views of O'ahu's windward cliffs (above). Take the Pali Highway (Route 61) between Honolulu and Kailua/Kāne'ohe, and exit at Nu'uanu Pali State Wayside.

About 2/3 mile (1 km) east is a highway pullout on the west-bound lane with this panoramic view (below).

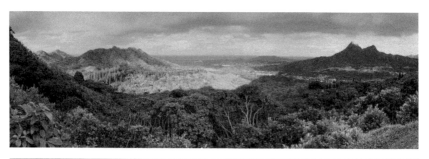

✉ **Addr:**	Nu'uanu Pali Dr, Kāne'ohe HI 96744	♀ **Where:**	21.367028 -157.792919
❷ **What:**	Overlook	◑ **When:**	Morning
◉ **Look:**	West	W **Wik:**	Nu'uanu_Pali

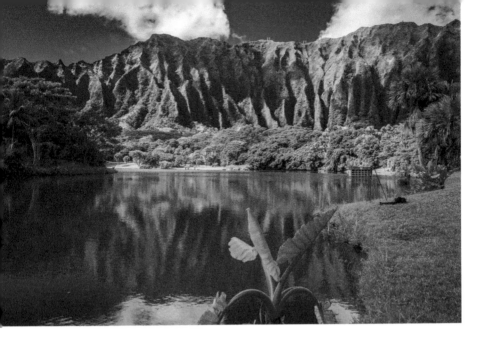

Hoʻomaluhia Botanical Garden offers a landscape seemingly straight from *The Lost World* (1912 Conan Doyle novel). This view is from the 32-acre Hoʻomaluhia Reservoir (Waokele Pond) looking south toward Nuʻuanu Pali Lookout.

Established in 1982 for flood protection, the rainforest garden is open daily, without charge, except for Christmas Day and New Year's Day.

✉ **Addr:**	45-680 Luluku Road, Kāneʻohe HI 96744	♀ **Where:**	21.390473 -157.805984	
❓ **What:**	Pond	☽ **When:**	Morning	
👁 **Look:**	South-southwest	W **Wik:**	Hoʻomaluhia_Botanical_Garden	

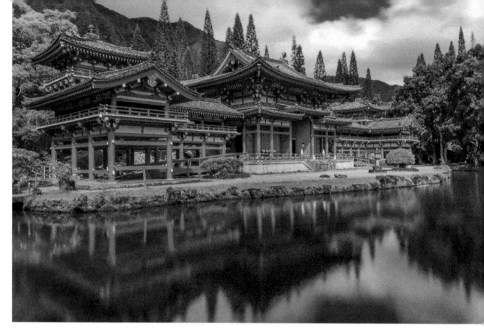

The **Byodo-In Temple** is a 1968 half-size-scale replica of the Phoenix Hall at Byodo-In temple in Japan, constructed in 1053. The Hawai'i version is more photogenic than the original, with a backdrop of dramatic green mountains contrasting with the bright red woodwork.

Morning is best, as the building faces east; in the afternoon, the sun is behind the mountains. You can use the approach bridge to lead the eye into your shot, and photograph from around the koi pond.

Located in a cemetery called the Valley of the Temples Memorial Park, this non-denominational Buddhist temple welcomes people of all faiths, and has appeared in TV shows such as *Lost, Hawaii Five-O* and *Magnum, P.I.*

There is a cash-only entrance fee of around $5 per adult.

✉ **Addr:**	47-200 Kahekili Hwy, Kāne'ohe HI 96744	♀ **Where:**	21.4308005 -157.8317872
❓ **What:**	Temple	◑ **When:**	Morning
👁 **Look:**	West	W **Wik:**	Byodo-In_Temple

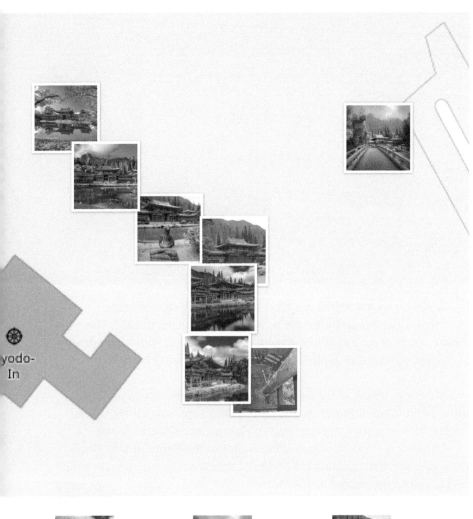

yodo-
In

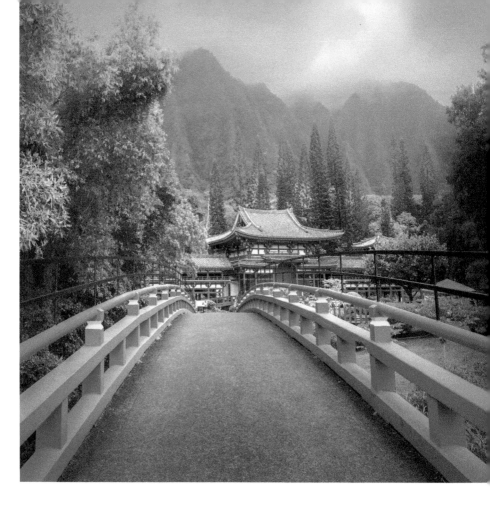

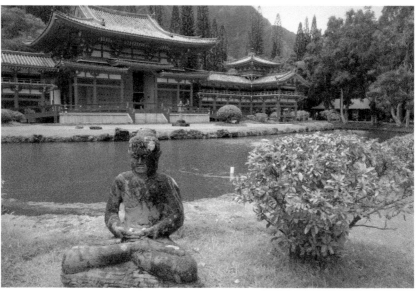

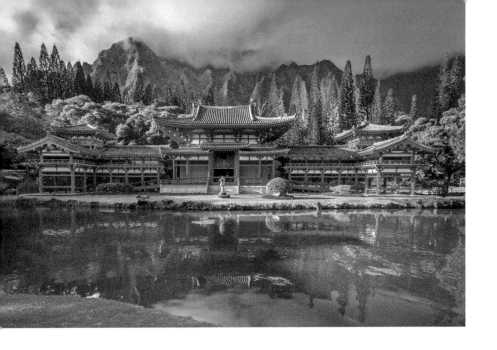

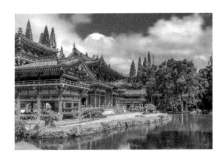

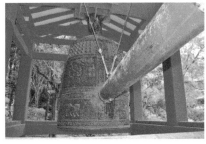

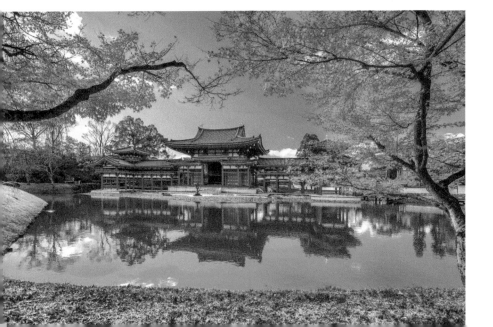

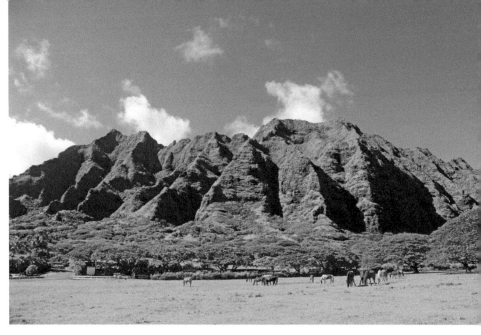

Kualoa is known for the rugged cliffs at **Kualoa Ranch**, a film location for *Jurassic Park, Pearl Harbor, Jumanji, Godzilla,* and *Lost*.

There is a public park and road from which you can photograph the hillside. The ranch itself is a private tourist attraction which offers a restaurant and paid tours.

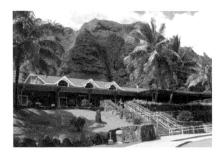

Located about 24 miles from Honolulu, and 32 miles from Haleiwa, Kualoa Ranch has about 4,000 acres of land, including three valleys: Ka'a'awa Valley, Kualoa Valley, and Hakipu'u Valley.

⊠ **Addr:**	49-560 Kamehameha Hwy, Kāne'ohe HI 96744	♀ **Where:**	21.521158 -157.8354725
❷ **What:**	Area	☾ **When:**	Anytime
👁 **Look:**	West	𝕎 **Wik:**	Kualoa_Ranch

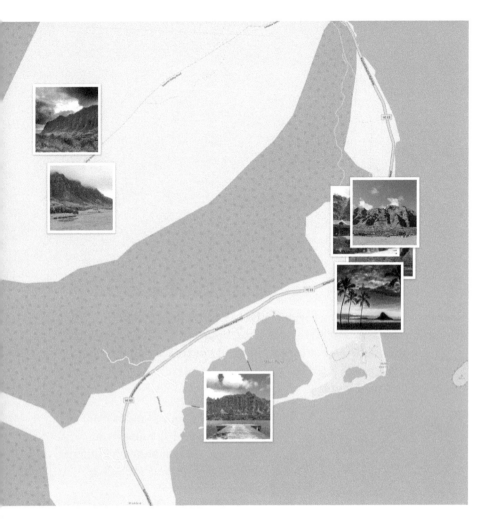

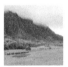

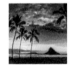
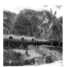

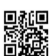

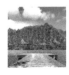

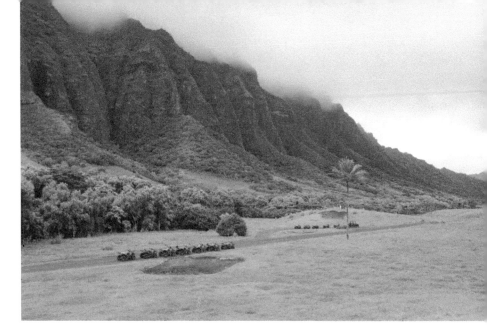

Above: An ATV tour at Kualoa Ranch. Below: The view from Moli'i Fishpond Pier.

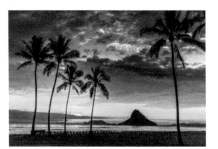
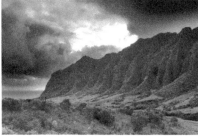

Above: Sunrise over the island of Mokoli'i from Kualoa Regional Park.

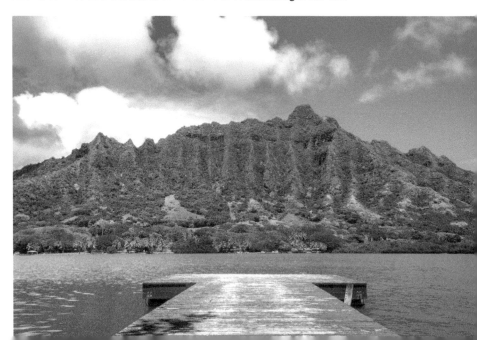

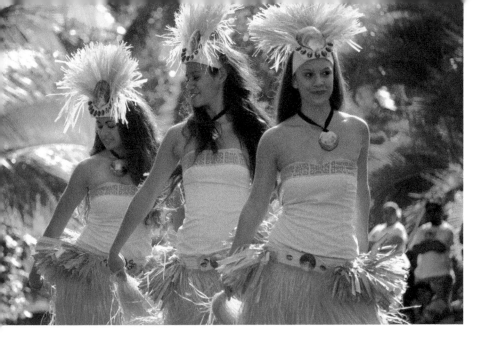

Polynesian Cultural Center is a Polynesian-themed living museum with eight simulated tropical villages. Performers demonstrate various arts and crafts from throughout Polynesia.

The 42-acre (17 ha) facility opened in 1963 and is owned by The Church of Jesus Christ of Latter-day Saints (LDS Church), with a university and the Laie Hawaiʻi Temple nearby.

Paid admission (>$50), closed Sundays.

✉ **Addr:**	55-370 Kamehameha Hwy, Laie HI 96762	♀ **Where:**	21.6390639 -157.9202694
❓ **What:**	Theme park	◑ **When:**	Afternoon
👁 **Look:**	North	W **Wik:**	Polynesian_Cultural_Center

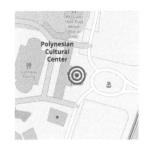

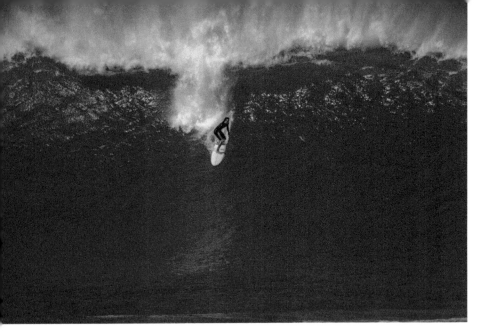

Banzai Pipeline is a surf reef break notorious for huge waves. You can photograph intrepid surfers at Ehukai Beach in Pūpūkea on Oʻahu's North Shore.

The waves are largest in winter, following storms in the North Pacific. In summer, the waves are smaller.

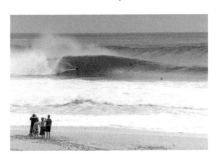 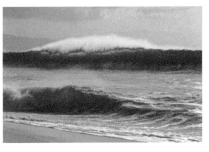

✉ **Addr:**	59 Kamehameha Hwy, Pūpūkea HI 96712	♀ **Where:**	21.663306 -158.052894
❓ **What:**	Surf break	◑ **When:**	Morning
👁 **Look:**	Northwest	W **Wik:**	Banzai_Pipeline

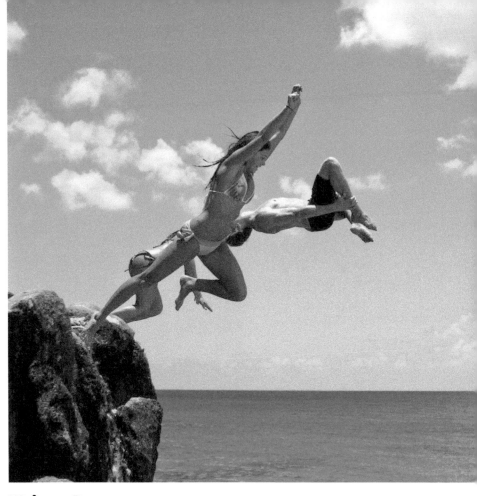

Waimea Bay is known for its Jump Rock (in the summer) and big-wave surfing (in the winter). The bay hosts the Quiksilver Big Wave Invitational when waves reach up 40 feet (12 m) high (summer has calm water).

✉ **Addr:**	Waimea Bay, Haleiwa HI 96712	♀ **Where:**	21.638626 -158.065056
❷ **What:**	Bay	◐ **When:**	Anytime
👁 **Look:**	Northwest	W **Wik:**	Waimea_Bay,_Hawai'i

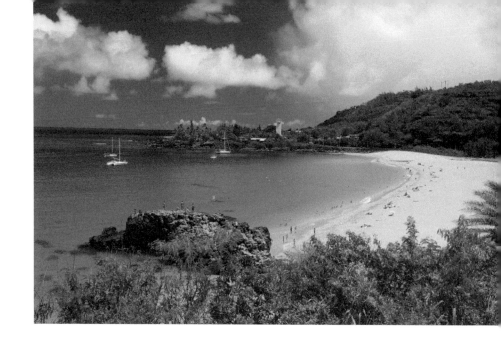

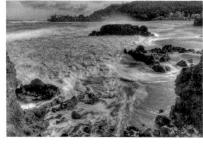

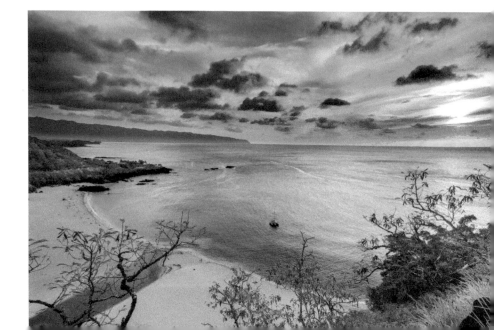

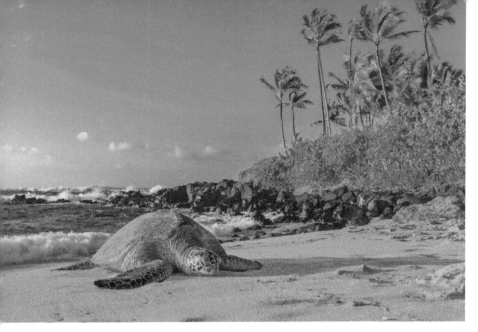

Laniākea Beach is also known as Turtle Beach for its popularity with green sea turtles, attracted to seaweed growing on the beach's rocky shelf. You can photograph the turtles in the water with an underwater bag or housing for your camera. Do not harass or get too close to the turtles.

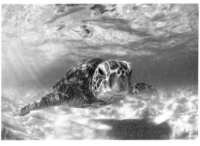

✉ **Addr:**	61-574 Pohaku Loa Way, Haleiwa HI 96712	♀ **Where:**	21.6186923 -158.0855306
❓ **What:**	Beach	☽ **When:**	Afternoon
👁 **Look:**	North-northeast	W **Wik:**	Green_sea_turtle

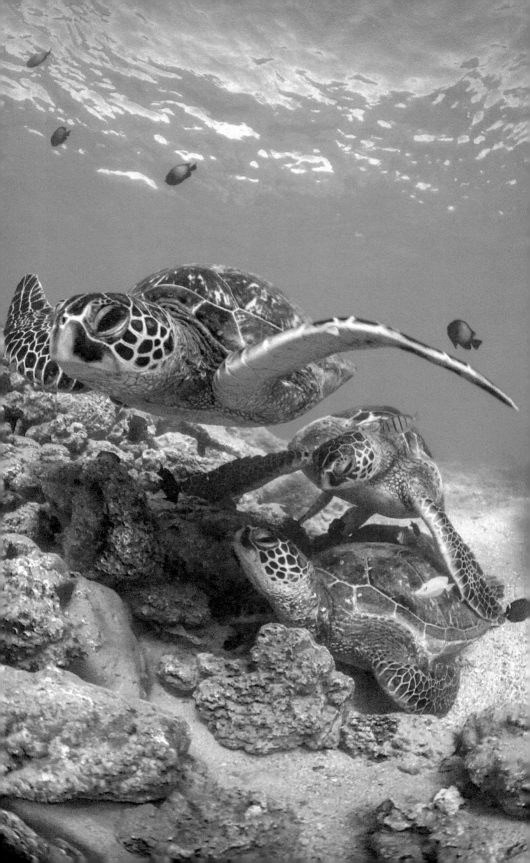

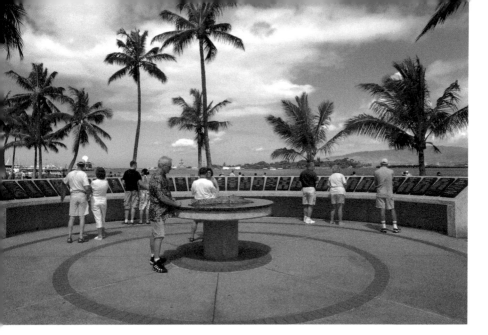

Pearl Harbor Historic Sites is a collection of memorials to the Pearl Harbor attacks in 1941, which killed over 2,400 Americans and sank twelve ships. At the visitor center on the mainland, exhibits include the Submarine Memorial (above) and torpedoes (below), and free boat rides [ticket required] depart for the USS Arizona Memorial.

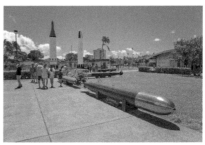

✉ **Addr:**	1 Arizona Memorial Pl, Honolulu HI 96818	♥ **Where:**	21.368245 -157.93889	
❓ **What:**	Area	☽ **When:**	Anytime	
👁 **Look:**	West-northwest	W **Wik:**	Pearl_Harbor_National_Memorial	

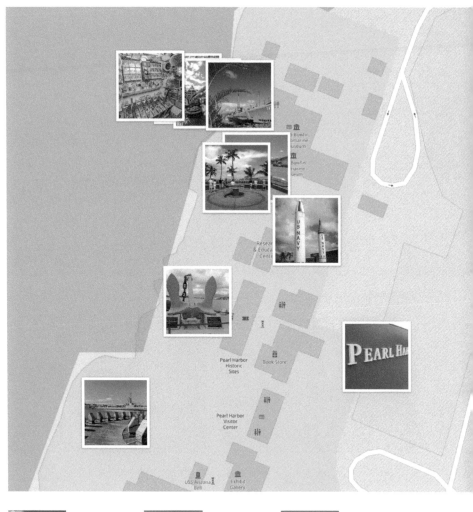

 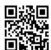 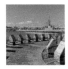

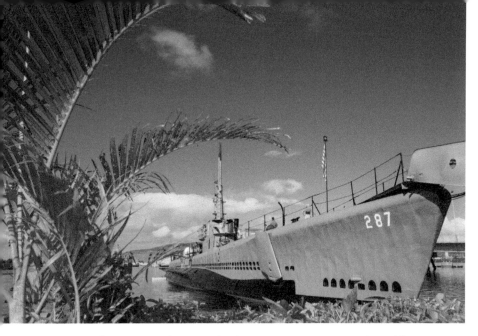

USS Bowfin is a 1942 submarine that is now a museum open to the public.

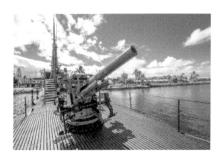 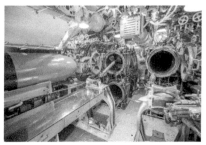

A 40 mm anti-aircraft gun, torpedo tubes, and the control room.

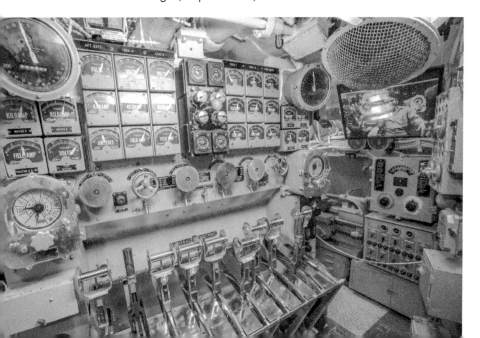

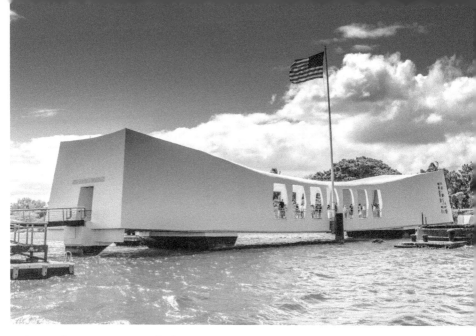

USS Arizona Memorial marks the resting place of 1,102 sailors and Marines killed on USS Arizona during the Japanese surprise attack on Pearl Harbor in 1941. Accessible only by boat, the 1962 memorial straddles the sunken hull of the battleship without touching it. Inside, you can see the ship below.

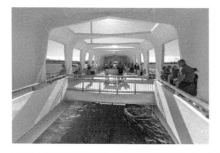
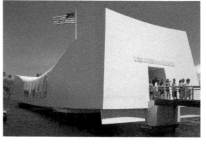

✉ **Addr:**	1 Arizona Memorial Pl, Honolulu HI 96818	♀ **Where:**	21.364775 -157.94914
❓ **What:**	Memorial	⏲ **When:**	Morning
👁 **Look:**	West	W **Wik:**	USS_Arizona_Memorial

na

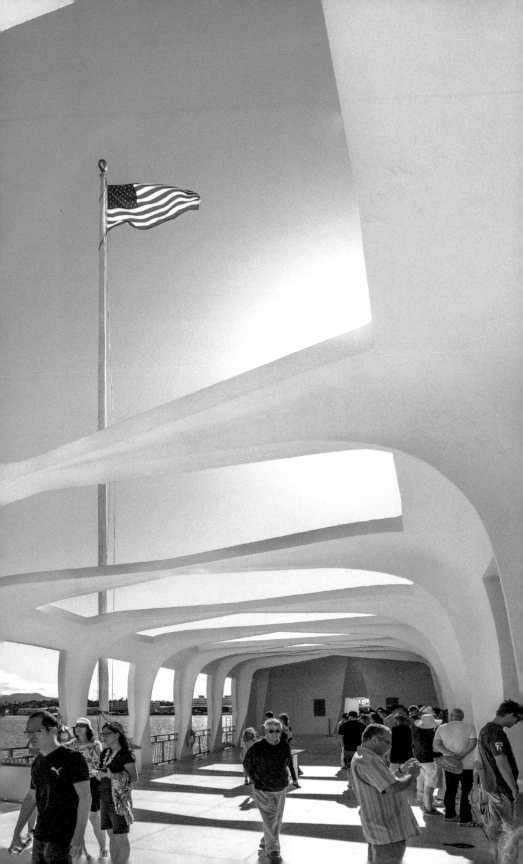

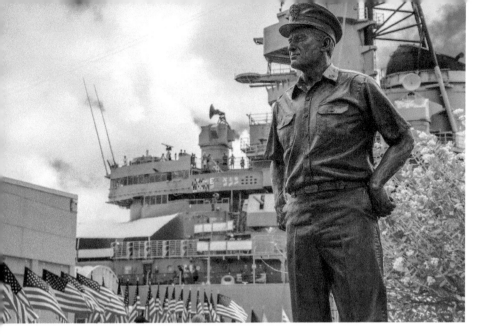

USS Missouri is the battleship upon which the Empire of Japan surrendered, ending World War II.

Completed in 1944 as the last U.S. battleship, the Missouri fought in the battles of Iwo Jima and Okinawa, in the Korean War, and in Operation Desert Storm. She is now a museum facing the USS Arizona.

At the entrance on Ford Island is a statue of Fleet Admiral Chester Nimitz, who led the U.S. Pacific Fleet and signed Japan's surrender for the U.S.

Standing on the ship's bow you can photograph the 16-inch (406 mm) gun turrets (next page).

✉ **Addr:**	63 Cowpens St, Honolulu HI 96818	♀ **Where:**	21.362727 -157.95405
❓ **What:**	Memorial	◑ **When:**	Afternoon
👁 **Look:**	Southeast	W **Wik:**	USS_Missouri_(BB-63)

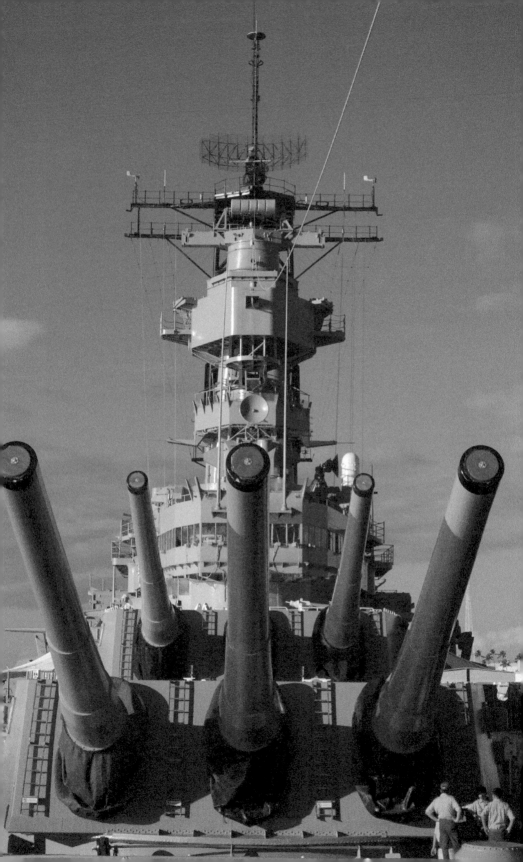

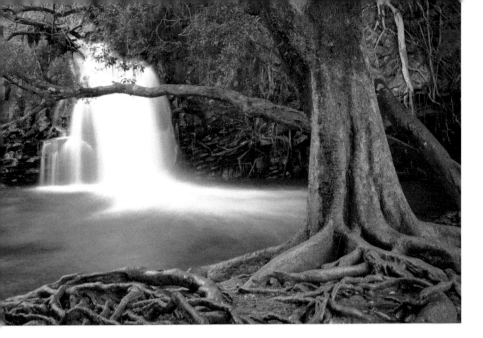

Twin Falls is a pair of scenic waterfalls off the Hāna Highway. From a parking lot northwest of the Hoolawa Stream Bridge, walk the flat, public trail through private property about 900 feet (300 m) to the lower waterfall. The second waterfall is a similar distance upstream. The trail can be closed during flooding and high water volume.

This shot uses a banyan tree in the foreground to partially frame the waterfall. As with other water subjects, use a slow shutter speed of around 1/8s to blur the water into a soft, romantic curtain. You'll need a tripod or other camera support to keep the camera steady and maintain a sharp shot.

✉ **Addr:**	6300 Hāna Hwy, Haiku HI 96708	♀ **Where:**	20.911202 -156.242924
❓ **What:**	Waterfall	☽ **When:**	Afternoon
👁 **Look:**	South	↔ **Far:**	30 m (100 feet)

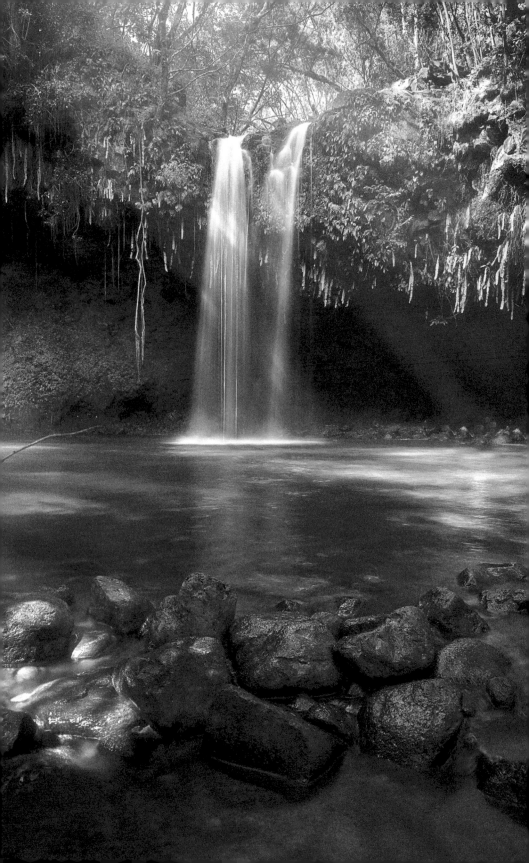

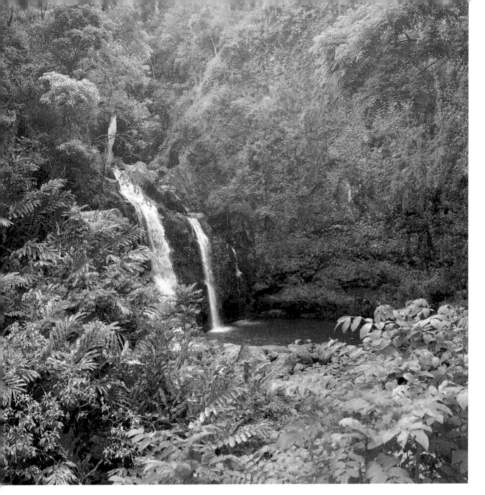

Upper Waikani Falls is a scenic waterfall just off the Hāna Highway, easily photographed from a small viewpoint right off the road (no parking). The waterfall is also known as Three Bears Falls.

✉ **Addr:**	Hāna Hwy, Haiku HI 96708	♀ **Where:**	20.832552 -156.13861
❓ **What:**	Waterfall	◑ **When:**	Morning
👁 **Look:**	South	↔ **Far:**	40 m (120 feet)

Hāna Lava Tube is the largest publicly-accessible lava tube on Maui.

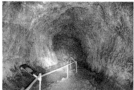

The tunnel formed around 960 years ago, when molten lava flowed underground then drained out, leaving a hardened crust above.

For an admission charge of about $12, you are provided with a flashlight to explore about 1/3 mile of the lava tube. Afterwards you can navigate a maze made of ti plants, the only one in the world.

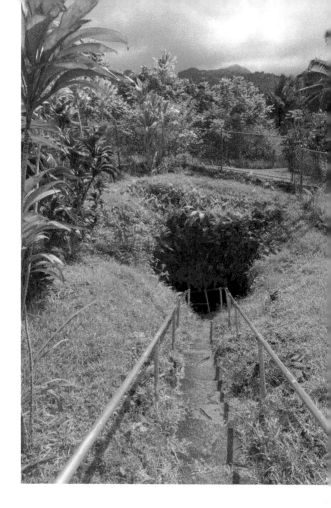

✉ **Addr:**	205 Ulaino Rd, Hāna HI 96713	♥ **Where:**	20.785223 -156.027839
❓ **What:**	Lava tube	◑ **When:**	Anytime
👁 **Look:**	South-southwest	↔ **Far:**	13 m (43 feet)

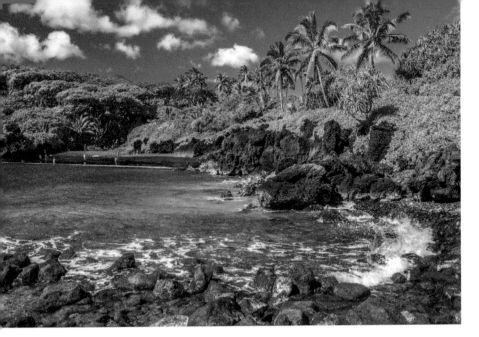

Waiʻanapanapa Beach has black volcanic sand, created when hot lava cooled quickly in the sea and shattered into pebbles.

Nearby are Waiʻanapanapa Sea Cave (a lava tube to the ocean), Waiʻanapanapa Blowhole, freshwater caves, an arch rock and hiking trails.

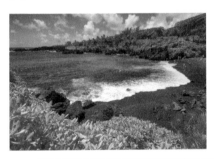

✉ **Addr:**	Waiʻanapanapa State Park, Hāna HI 96713	♀ **Where:**	20.789324 -156.002747
❓ **What:**	Beach	☾ **When:**	Morning
👁 **Look:**	Southwest	↔ **Far:**	100 m (320 feet)

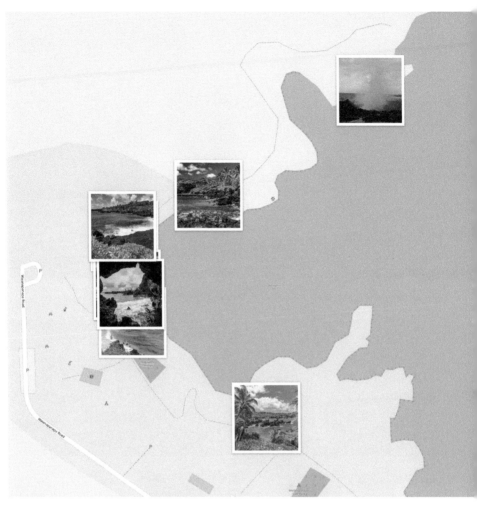

 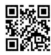

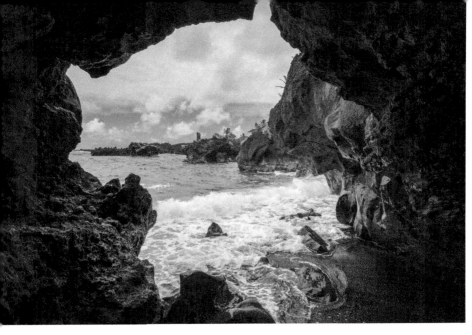

A lava tube opens into the ocean to frame your shot like a sea cave.

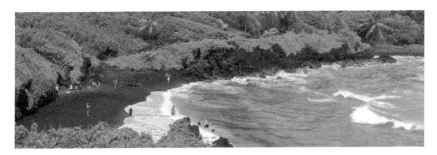

A trail through Honokalani Cemetery leads to exotic views.

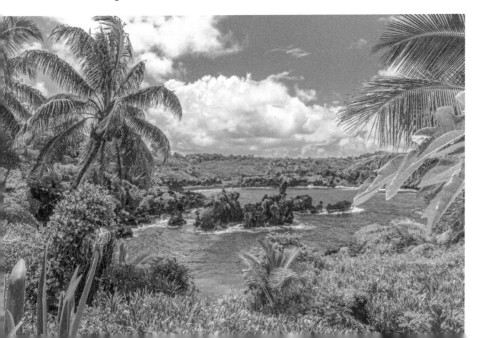

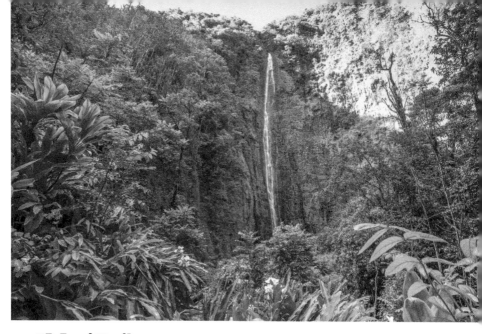

The **Pīpīwai Trail** is a two-mile (3.2 km) hiking trail that leads to Waimoku Falls. Starting at the Kīpahulu Visitor Center in Haleakalā National Park [paid admission, around $25 per car], the two-mile (3 km) trail passes Makahiku Falls and a giant banyan tree, and winds through a bamboo forest.

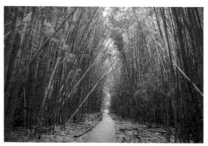

✉ **Addr:**	Pīpīwai Trail, Hāna HI 96713	♀ **Where:**	20.675381 -156.056081
❓ **What:**	Trail	☽ **When:**	Morning
👁 **Look:**	North	Ⓦ **Wik:**	Pīpīwai_Trail

Maui > East Maui > South Shore > Haleakalā National Park > Kīpahulu District > Kīpahulu Visitor Center > Pīpīwai Trail

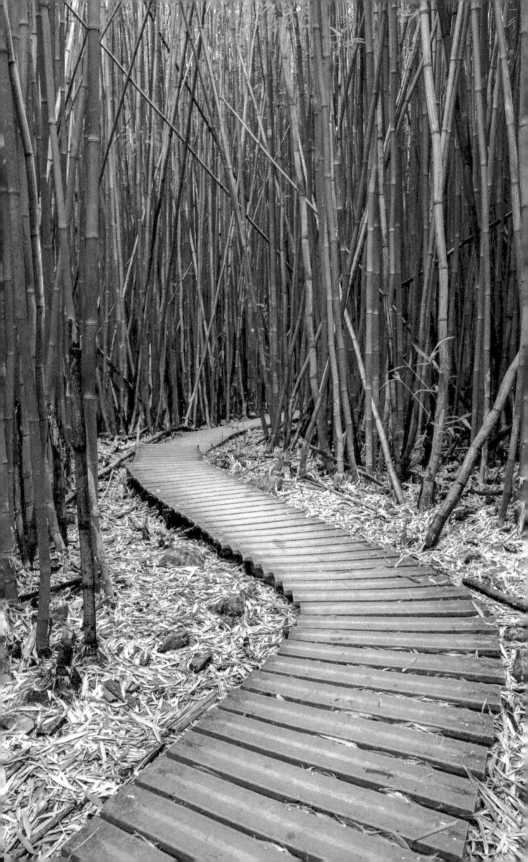

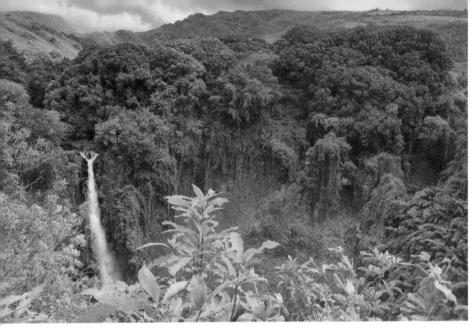

Makahiku Falls from an overlook about 1/2 mile (800 m) along the trail.

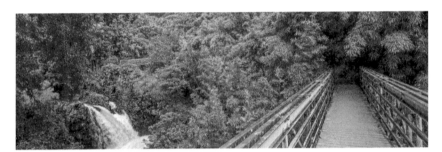

The Palikea Stream Bridge at one mile (1.6 km) has a view of a smaller waterfall.

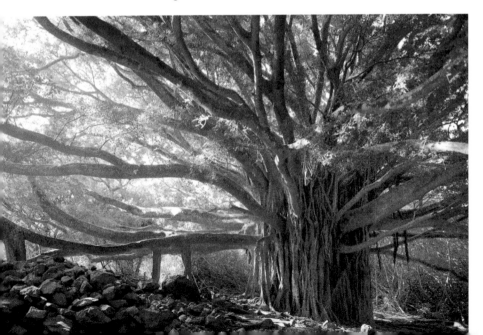

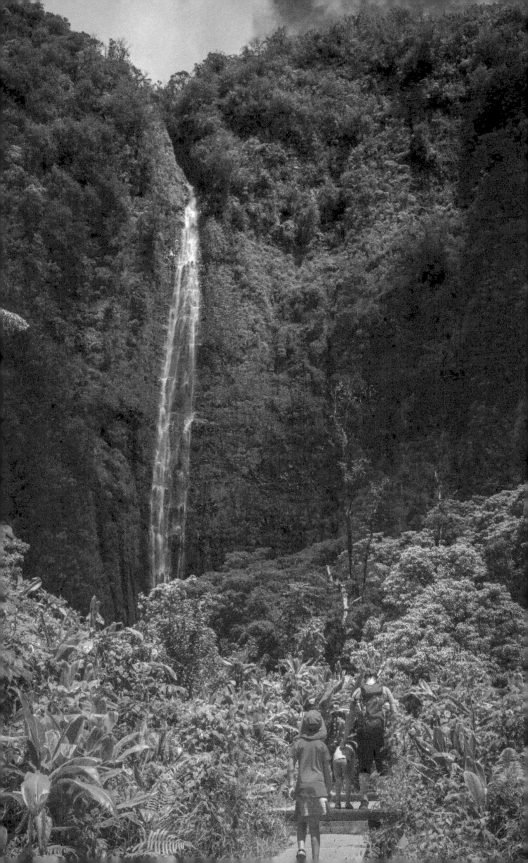

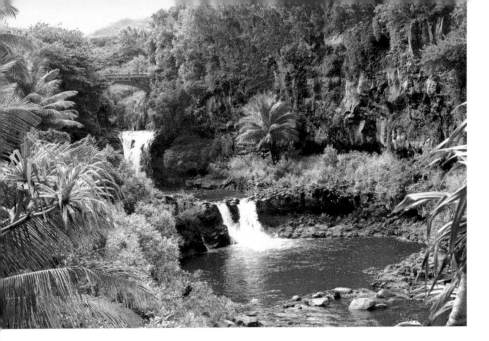

Pools of ʻOheʻo are a delightful series of waterfalls under a highway bridge, flowing to the ocean. Also called the Seven Sacred Pools, they are a short and easy 1/3-mile (600 m) hike from the Kīpahulu Visitor Center along Kūloa Point Trail (by the Pīpīwai Trail).

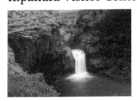

✉ **Addr:**	ʻOheʻo Gulch, Hāna HI 96713	♀ **Where:**	20.663342 -156.042622
❓ **What:**	Pool	☾ **When:**	Morning
👁 **Look:**	Northwest	↔ **Far:**	60 m (200 feet)

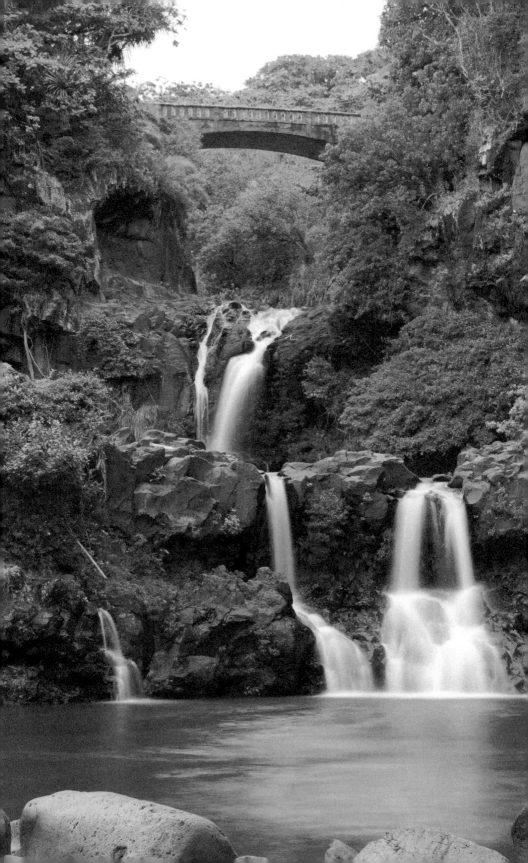

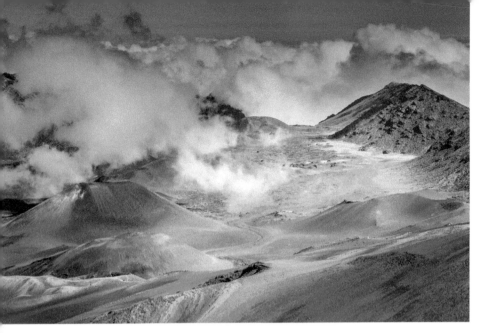

Haleakalā, or the East Maui Volcano, is a massive shield volcano that forms more than 75% of the island of Maui.

Reservations are required to watch the sunrise, but not the sunset. Haleakalā National Park has a paid admission of around $25 per car.

✉ **Addr:**	Haleakalā Hwy, Kula HI 96790	♀ **Where:**	20.7150689 -156.2497914
❓ **What:**	Shield volcano	☽ **When:**	Afternoon
👁 **Look:**	East-northeast	W **Wik:**	Haleakalā

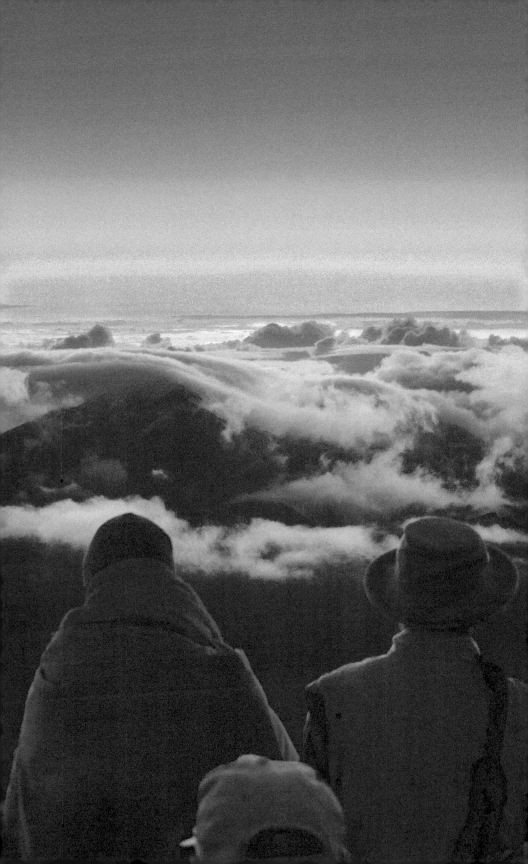

 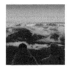

 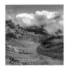

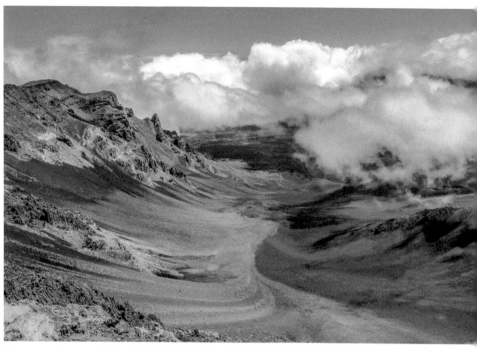

The views from the Visitors Center (above) and from nearby Pā Kaʻooa (below).

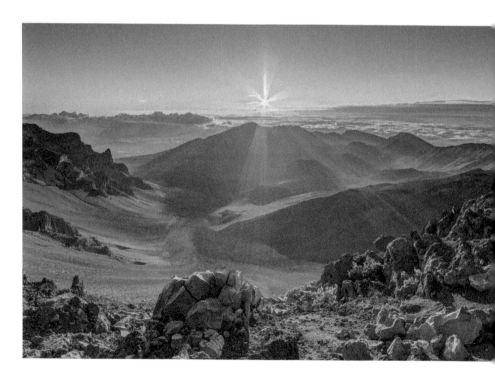

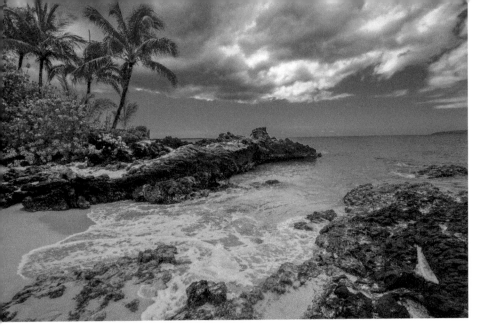

Makena Cove is a small cove popular for beach weddings, with its white sand, black lava rock, turquoise water, and palm trees. Also known as Secret Cove and Paako Cove, access is through a stone wall between homes on Makena Road.

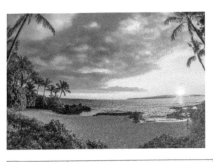

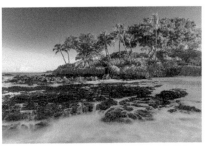

✉ **Addr:**	6468 Makena Road, Kihei HI 96753	♀ **Where:**	20.626885 -156.443236
❓ **What:**	Beach	◑ **When:**	Morning
👁 **Look:**	South	↔ **Far:**	50 m (150 feet)

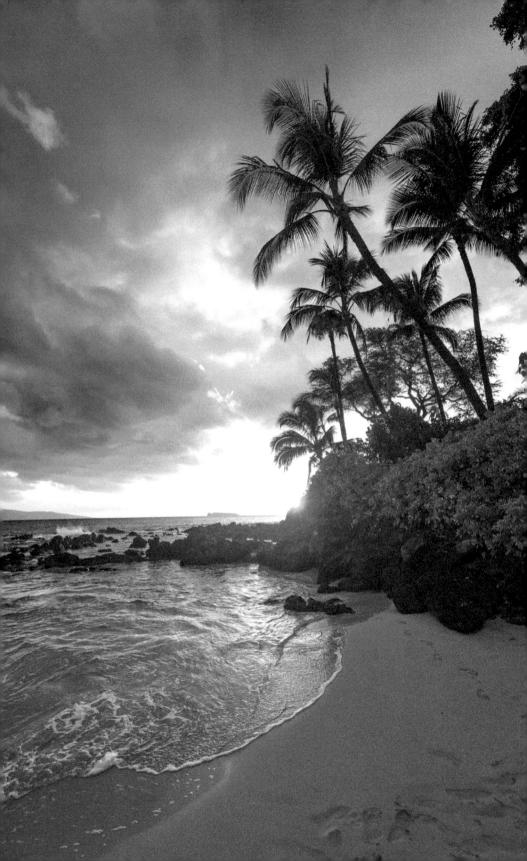

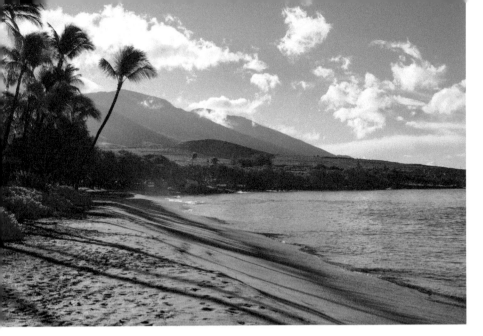

Lāhainā was the capital of the Kingdom of Hawai'i from 1820 to 1845 and the center of the global whaling industry in the 19th century.

Near the historic port is the largest banyan tree in the United States, planted in 1873. Lāhainā's Front Street was ranked one of the "Top Ten Greatest Streets" by the American Planning Association.

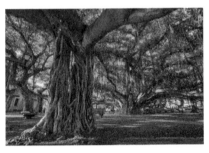

✉ **Addr:**	113 Ulupono St, Lāhainā HI 96761	📍 **Where:**	20.871742 -156.677629
❓ **What:**	Census-designated place	🕐 **When:**	Anytime
👁 **Look:**	North	W **Wik:**	Lāhainā,_Hawai'i

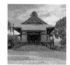

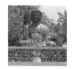

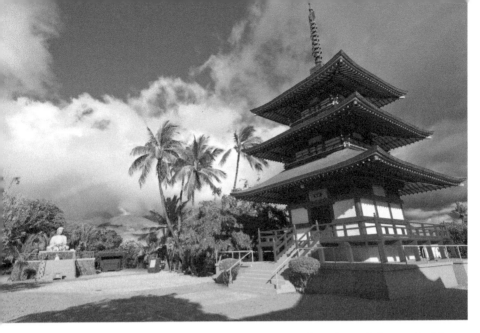

The Lāhainā Jodo Mission has a red Japanese pagoda and a 12-ft. bronze Buddha.

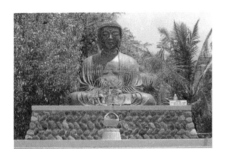 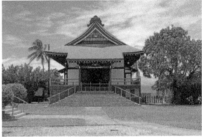

The Sugar Cane Train is a steam-powered, 3 ft narrow gauge heritage railroad.

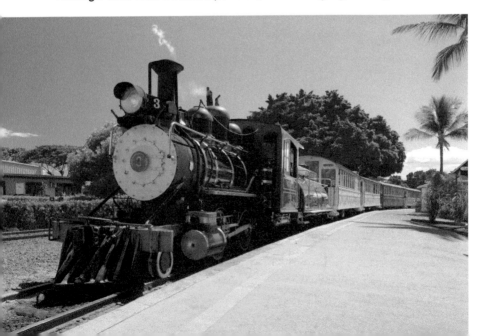

Kā'anapali Beach is a mile-long beach on the western shore of Maui, a few miles north of Lāhainā. There are six major resort hotels here, and by the Marriott Maui Ocean Club is a pair of diagonally-growing palm trees which make a great exotic backdrop to a tropical beach shot.

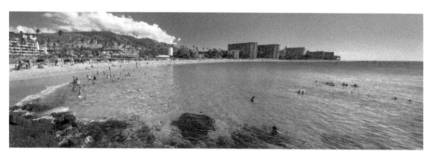

✉ **Addr:**	Kā'anapali Pkwy, Lāhainā HI 96761	◉ **Where:**	20.9152955 -156.6961026
❓ What:	Beach	◑ **When:**	Morning
👁 **Look:**	Northwest	Ⓦ **Wik:**	Kā'anapali,_Hawai'i

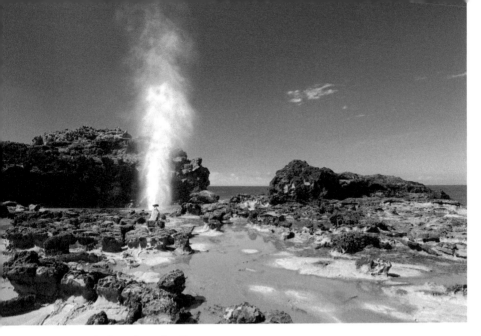

Nakalele Blowhole produces powerful geyser-like water spouts up to 100 feet (30 m) in the air, as waves shoot through lava tubes.

There is a short but hazardous 250 foot (75 m) hike around sharp volcanic rock. Do not stand near the cliff edge as the rocks are slippery and rogue waves occur.

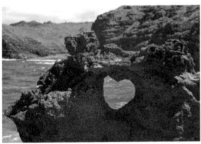

About 180 feet (60 m) south is a rock window shaped like a heart.

✉ **Addr:**	Poelua Bay, Wailuku HI 96793	♀ **Where:**	21.026372 -156.589165
❓ **What:**	Blowhole	◑ **When:**	Afternoon
👁 **Look:**	East-northeast	Ⓦ **Wik:**	Nakalele_Point

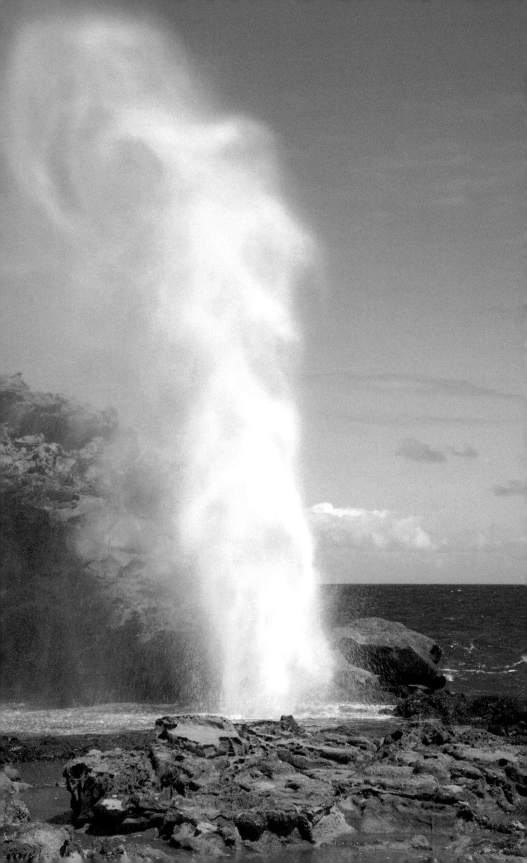

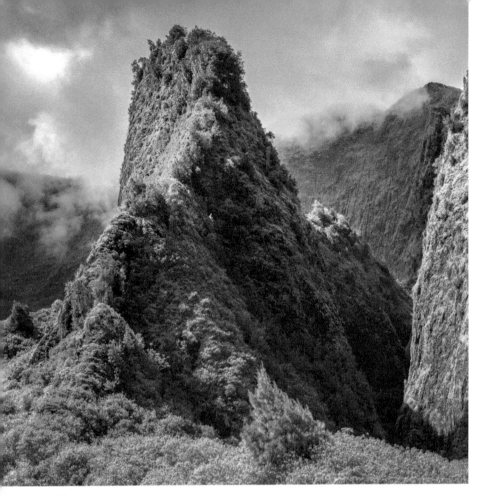

ʻĪao Needle is a vegetation-covered lava ridge rising 1,200 feet (370 m) from the valley floor, taller than the Eiffel Tower. The Needle can be viewed from an overlook (above) following a short trail (which crosses a stream, next page) at ʻĪao Valley State Monument.

✉ **Addr:**	54 S High St, Wailuku HI 96793	♀ **Where:**	20.880498 -156.54666	
❓ **What:**	Rock	☾ **When:**	Morning	
👁 **Look:**	Northwest	W **Wik:**	Iao_Valley	

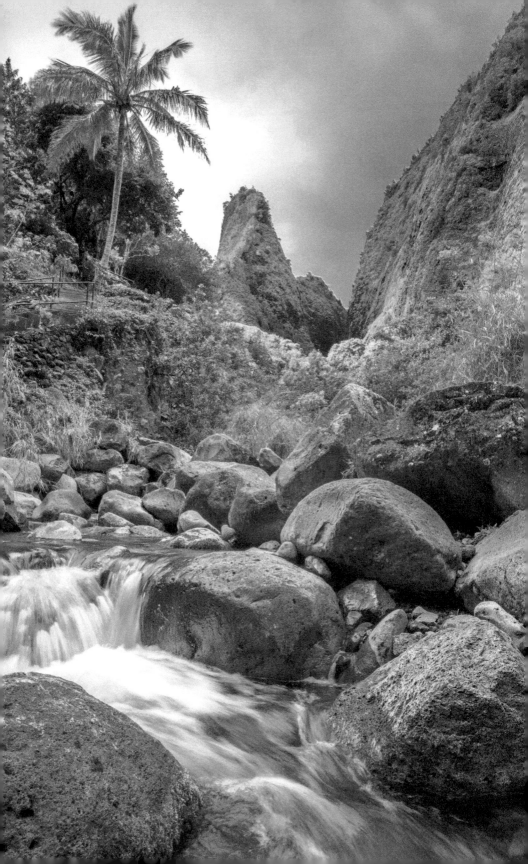

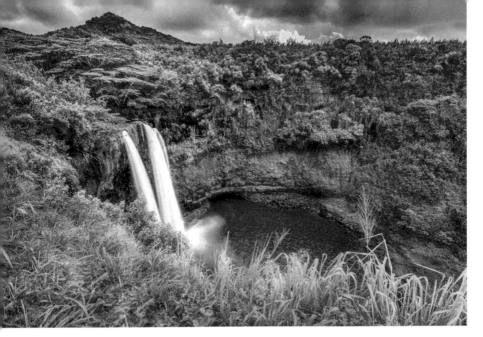

Wailua Falls is a 173-foot (52 m) tall waterfall used in the TV show *Fantasy Island* (1977–84). You can drive to the main viewpoint (above), about five miles (8 km) north of Lihue on Maalo Road. Morning is best, as the sunlight can shine through the mist to create a rainbow. A quarter-mile back along the road is a trail to the pool.

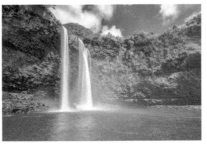

✉ **Addr:**	Maalo Rd, Kapaʻa HI 96746	♀ **Where:**	22.033996 -159.378831
❷ **What:**	Waterfall	◑ **When:**	Afternoon
👁 **Look:**	North-northeast	W **Wik:**	Wailua_Falls

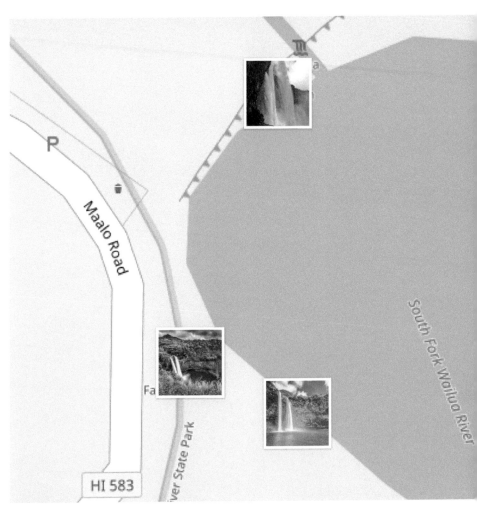

P

Maalo Road

HI 583

River State Park

Fa

South Fork Wailua River

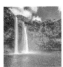

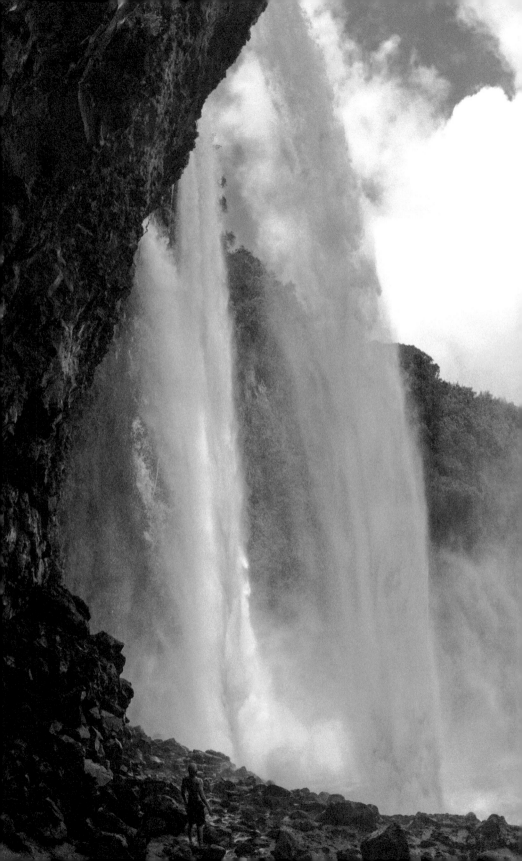

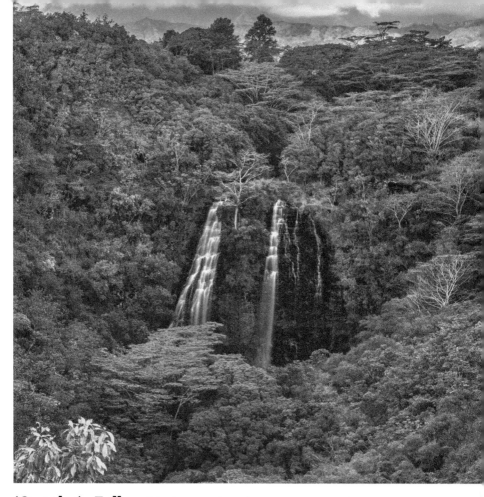

'Opaeka'a Falls is fabulous and easily photographed from a road-side parking area. The 150-foot-tall, 40-foot-wide waterfall is in Wailua, off Kuamoo Road and by Wailua River State Park.

✉ **Addr:**	Kuamoo Road, Wailua HI 96746	♀ **Where:**	22.046303 -159.359079
❷ **What:**	Waterfall	◑ **When:**	Morning
👁 **Look:**	Northwest	W **Wik:**	%27Opaeka%27a_Falls

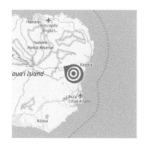 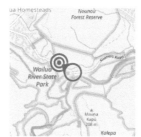 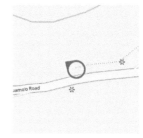

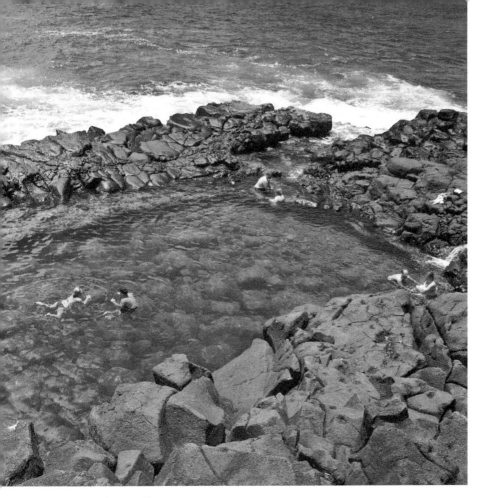

Queen's Bath is a large tide pool surrounded by igneous rock. Located in Princeville, the pool is a 1/3-mile (600 m) hike from a parking lot on Kapiolani Loop. This area is dangerous and people have drowned when swept off the rocks by unexpected waves.

✉ **Addr:**	3769 Punahele Rd, Princeville HI 96722	♀ **Where:**	22.228992 -159.487278	
❷ **What:**	Tide pool	☾ **When:**	Morning	
👁 **Look:**	West-northwest	W **Wik:**	Queen%27s_Bath	

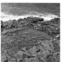
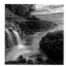

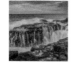

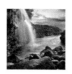

Above: Near the Queen's Bath tide pool is a lava ledge where seawater pours down. Below and next page: About 700 feet (200 m) east is a small romantic waterfall with a stream emptying into the ocean. Beware of slippery rocks and rogue waves.

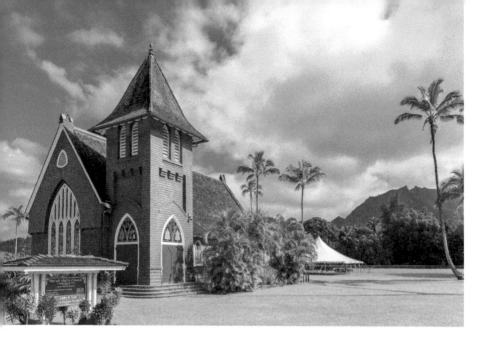

Wai'oli Hui'ia Church was built in 1912 as part of the historic Wai'oli Mission in Hānalei. The 17-acre (6.9 ha) Wai'oli Mission District includes the 1836 mission house, the 1841 mission hall, two caretaker cottages, and the Hui'ia Church.

This night shot with the Milky Way is taken from near the roadside, using a tripod and long exposure.

✉ **Addr:**	5-5331 Kūhiō Hwy, Hānalei HI 96714	♀ **Where:**	22.201399 -159.501309
❓ **What:**	Church	◑ **When:**	Afternoon
👁 **Look:**	East-southeast	Ⓦ **Wik:**	Wai'oli_Mission_District

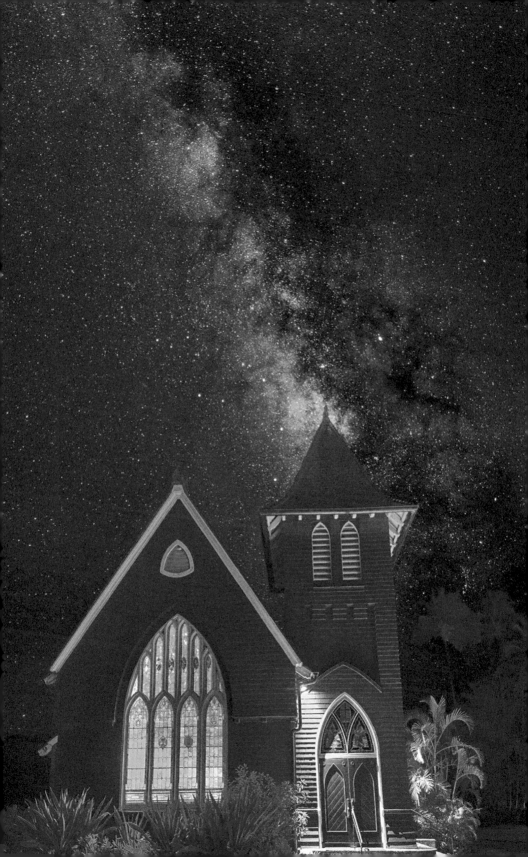

Hānalei Bay is the largest bay on the north shore of Kauaʻi, stretching nearly two miles. At the north end (Black Pot Beach) is Hānalei Pier, 340 feet (100 m) long with a shed roof at the end.

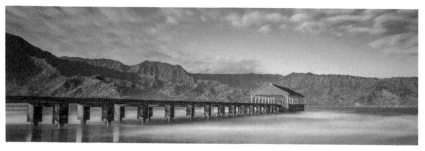

✉ **Addr:**	4906 Weke Rd, Princeville HI 96722	♀ **Where:**	22.211915 -159.497256
❓ What:	Bay	☽ **When:**	Anytime
👁 **Look:**	South-southwest	𝕎 **Wik:**	Hānalei_Bay

Mākua Beach is also known as Tunnels Beach, for the many lava tubes that scuba divers find in the bay. Crowning the view is Makana mountain, soaring 1,115 feet (340 m) above Limahuli Valley. The area surrounding the beaches is vegetated by ironwood trees, coconut palms, ti, and guava.

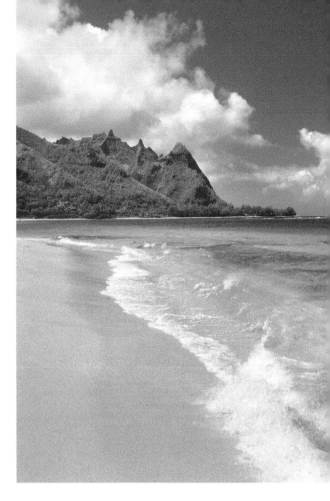

✉ **Addr:**	5-7652 Kūhiō Hwy, Hānalei HI 96714	♀ **Where:**	22.224436 -159.560323
❷ **What:**	Beach	◑ **When:**	Morning
👁 **Look:**	West	↔ **Far:**	1.27 km (0.79 miles)

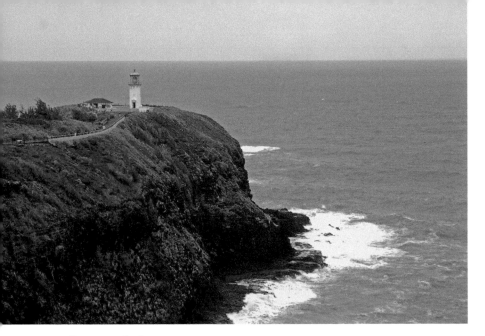

Kīlauea Light is located on Kīlauea Point, a picturesque lava peninsula on the north shore of Kauaʻi. Dedicated in 1913, the Classical Revival lighthouse is 52 feet (16 m) high and has a second-order Fresnel lens made in Paris, France.

The entrance road has a viewpoint of the headland (above and below).

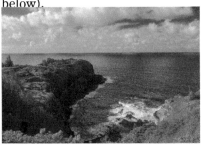
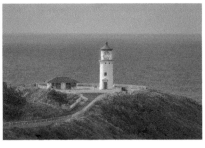

✉ **Addr:**	3500 Kīlauea Rd, Kīlauea HI 96754	♀ **Where:**	22.227783 -159.401182	
❷ **What:**	Lighthouse	◑ **When:**	Morning	
👁 **Look:**	North	W **Wik:**	Kīlauea_Light	

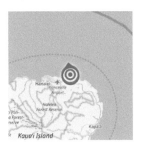

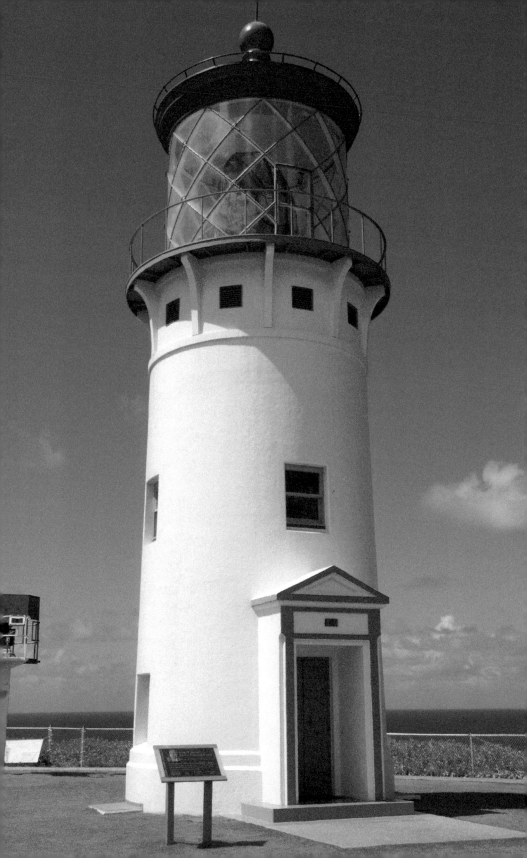

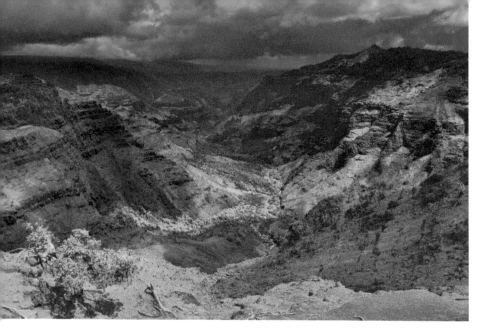

Waimea Canyon is known as the "Grand Canyon of the Pacific." Several valleys feed into the main gorge which is ten miles (16 km) long and up to 3,000 feet (900 m) deep.

Waimea Canyon can be photographed from several viewpoints between mile markers 10 and 14 along state route 550 (Kākeʻe Road), from Waimea. The first lookout is Waimea Canyon Overlook at mile 10, with a parking lot, a large concrete viewing area, and a side-on view of the canyon. The photo on the next page is from this viewpoint, looking up Kawaiiki Valley.

To your left is Waipoʻo Falls which can be photographed from small pullouts between mile markers 12 and 13.

Puʻu Hinahina Lookout at mile 13.5 has a parking lot and a view down Waimea Canyon (above).

✉ **Addr:**	State Hwy 550, Waimea HI 96796	♀ **Where:**	22.108663 -159.669156	
❓ **What:**	State park	⏲ **When:**	Anytime	
👁 **Look:**	South-southeast	W **Wik:**	Waimea_Canyon_State_Park	

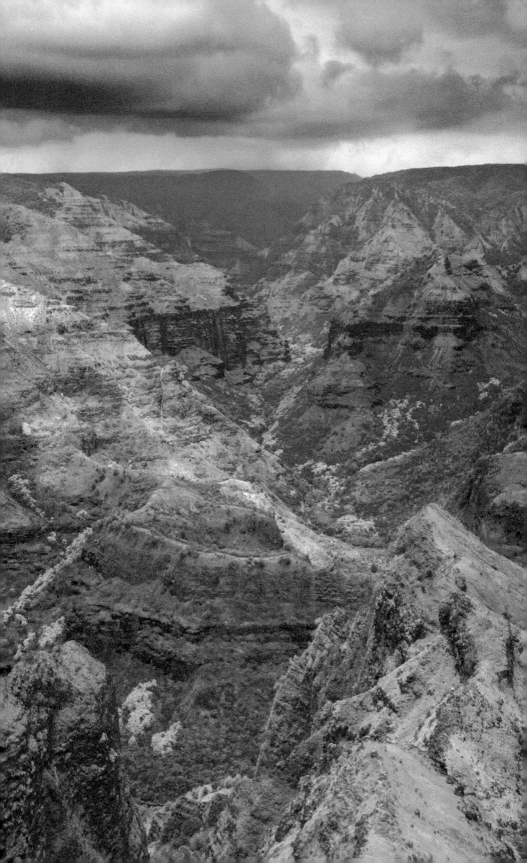

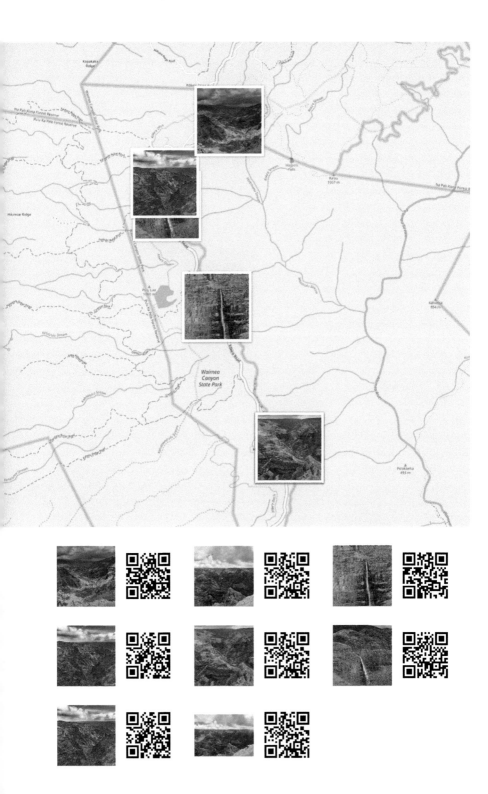

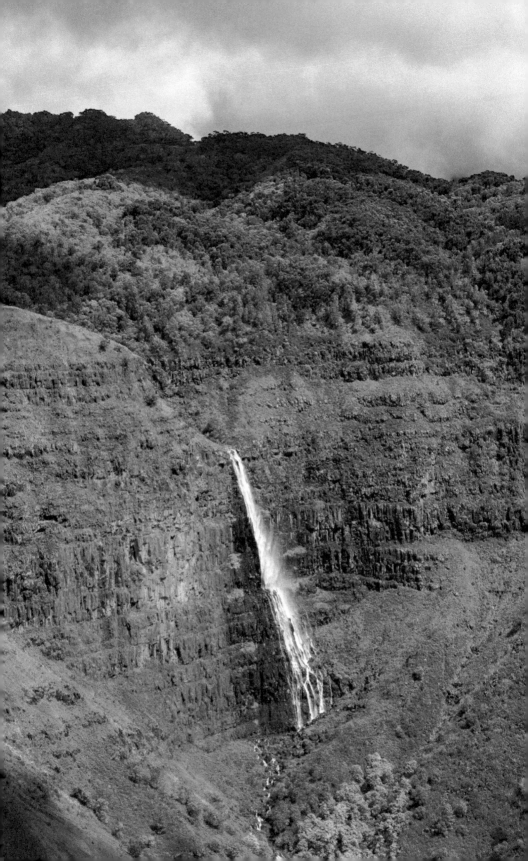

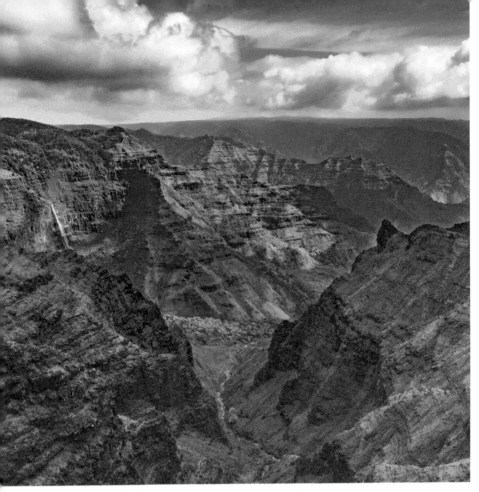

Above: Waipoʻo Falls from a small viewpoint at mile 13.
Below: The view from Waimea Canyon Overlook. Including people on the right adds a sense of scale to the scenery.

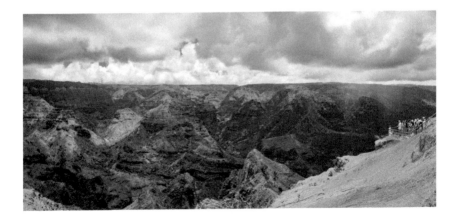

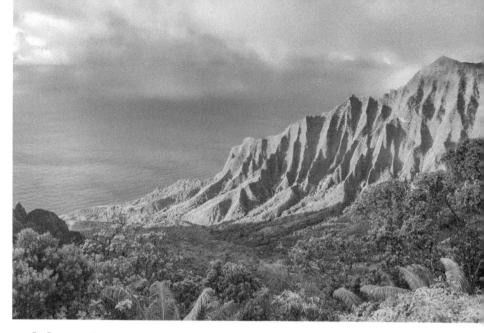

Kalalau Valley on the Nā Pali Coast is surrounded by rugged and ridged cliffs more than 2,000 feet (610 m) high. Continuing from Waimea Canyon on state route 550, there are two lookouts with parking lots: Kalalau Lookout at mile 18 with a viewing platform, and Puʻu O Kila Lookout at mile 19 with a trail viewpoint.

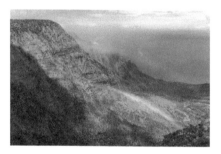
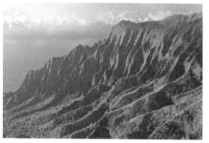

✉ **Addr:**	State Hwy 550, Waimea HI 96796	♥ **Where:**	22.1511502 -159.6459633	
❷ **What:**	Group	◑ **When:**	Anytime	
👁 **Look:**	North-northeast	Ⓦ **Wik:**	Kalalau_Valley	

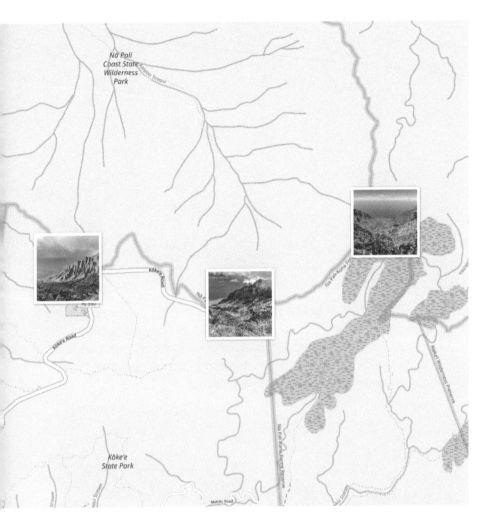

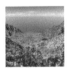

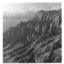

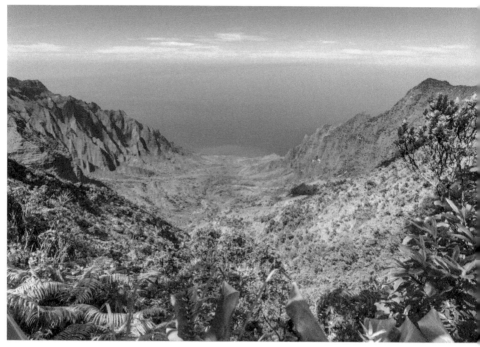

Above: Pihea Vista looks straight down Kalalua Valley. This is a one-mile (1.6 km) hike east on the Pihea Trail from Puʻu O Kila Lookout.
Below: The view from Puʻu O Kila Lookout, at the end of state route 550 (mile 19).

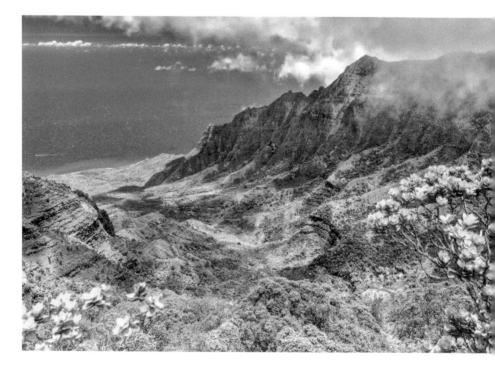

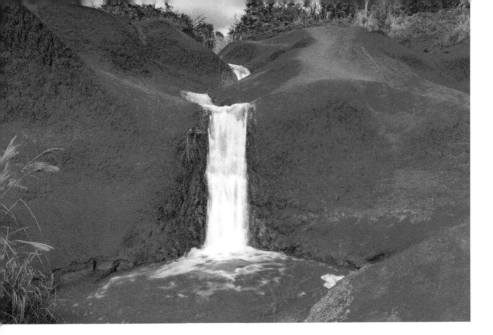

Red Dirt Falls is a seasonal waterfall in Waimea Canyon State Park. During spring after substantial rain, water cascades through a sienna-red landscape which looks more like Mars or the American southwest.

The waterfall is by Waimea Canyon Drive (state route 550), on your way to Waimea Canyon and Kalalau Valley. Park at the small pullout on the right side of the road and cross to the left side for this shot.

✉ **Addr:**	State Hwy 550, Waimea HI 96796	📍 **Where:**	22.008569 -159.677028
❓ **What:**	Waterfall	🌙 **When:**	Morning
👁 **Look:**	North	↔ **Far:**	17 m (56 feet)

Manawaiopuna Falls is where John Hammond's helicopter arrived in Jurassic Park (1993). The 400 foot (122 m) tall waterfall is in private property and only accessible by helicopter. Normally I don't put hard-to-get photos in these books but this amazing sight deserved an exception.

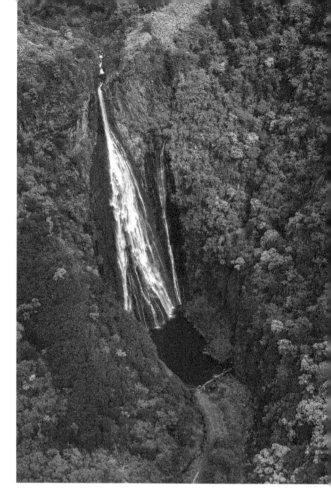

✉ **Addr:**	Kalaheo, Eleele HI 96705	♀ **Where:**	21.988 -159.525942		
❓ **What:**	Waterfall	◑ **When:**	Afternoon		
👁 **Look:**	Northeast	W **Wik:**	Manawaiopuna_Falls		

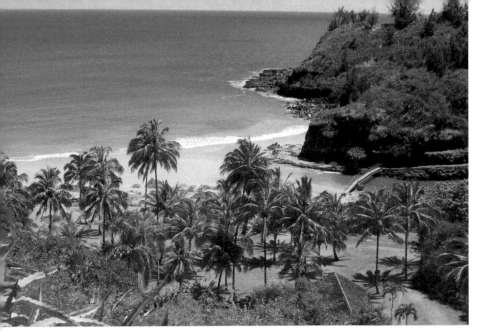

Allerton Garden, also known as Lāwaʻi-kai, is a botanical garden on the south shore of Kauaʻi. Created by Robert Allerton and and John Gregg Allerton, the 80-acre garden winds along Lāwaʻi Stream and includes the tree where egg shells were found in *Jurassic Park* (1993) and Sam Neill realized "the dinosaurs are breeding."

✉ **Addr:**	4425 Lāwaʻi Rd, Koloa HI 96756	♀ **Where:**	21.8857417 -159.4925111
❷ **What:**	Botanical garden	◑ **When:**	Afternoon
👁 **Look:**	East-southeast	W **Wik:**	Allerton_Garden

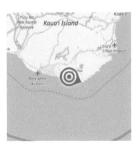 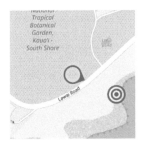

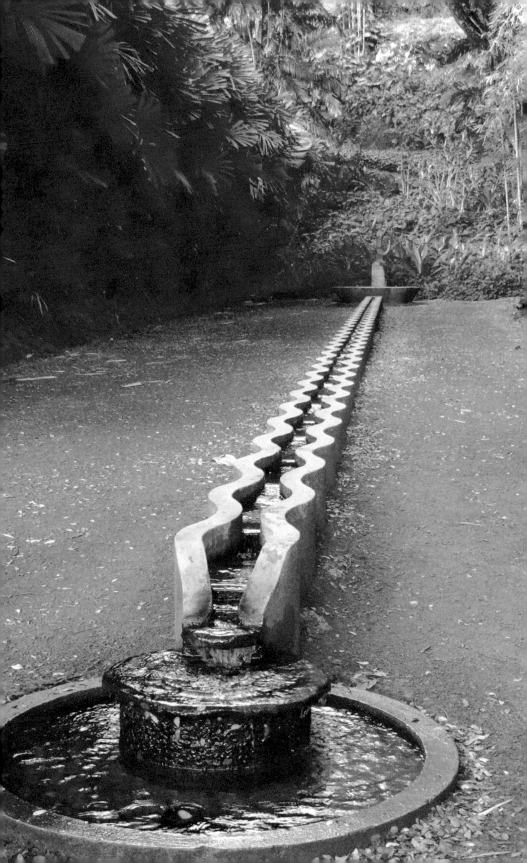

Spouting Horn

shoots water up to 50 feet (15 m) in the air by channeling waves through the narrow opening of eroded lava rocks.

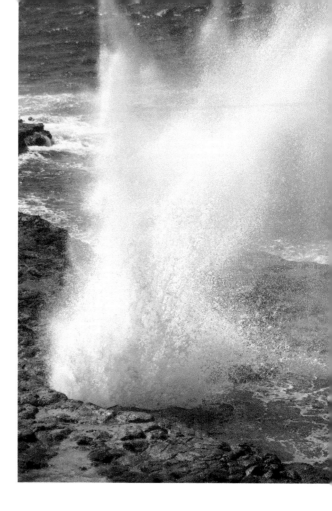

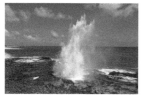

The blowhole is easily photographed from a concrete viewing platform at Spouting Horn Park, off Lāwaʻi Road in Koloa.

✉ **Addr:**	Lāwaʻi Rd, Koloa HI 96756	♀ **Where:**	21.8849362 -159.4936107		
❷ **What:**	Blowhole	◑ **When:**	Afternoon		
👁 **Look:**	Southeast	Ⓦ **Wik:**	Spouting_Horn		

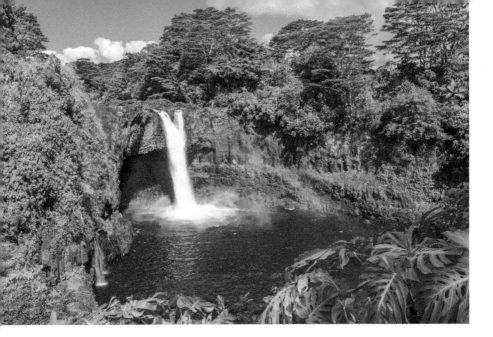

Rainbow Falls is an easily-photographed, idyllic waterfall in Hilo. Surrounded by tropical rainforest, water drops 80 feet (24 m) over a natural lava cave, into a turquoise-colored pool.

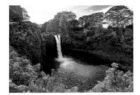

Known in the Hawaiian language as Waiānuenue (literally "rainbow water") for the rainbows that can be seen in the mist on sunny days around 10am, the waterfall is 1.7 miles (3 km) west of downtown Hilo. There is a paved viewing area next to a parking lot at Wailuku River State Park.

✉ **Addr:**	Rainbow Falls, Hilo HI 96720	♀ **Where:**	19.719293 -155.108379
❓ **What:**	Waterfall	◑ **When:**	Morning
👁 **Look:**	West	W **Wik:**	Rainbow_Falls_(Hawai'i)

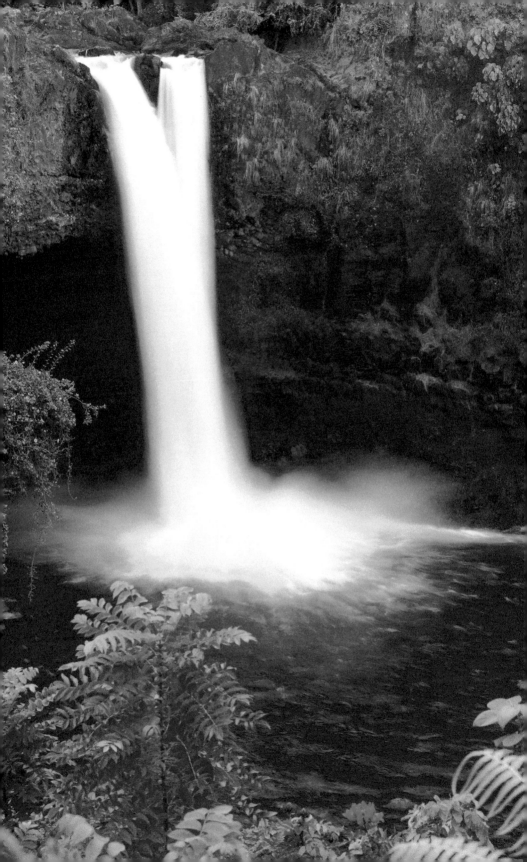

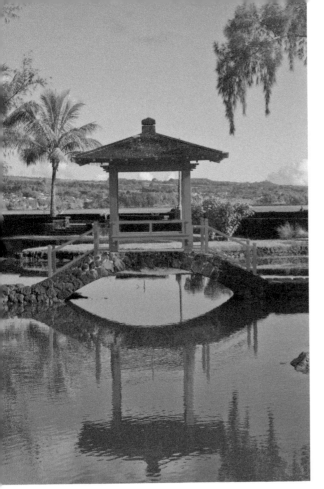

Lili'uokalani Park and Gardens

includes Edo-style Japanese gardens, built 1917-1919, and said to be the largest such gardens outside Japan. There is a small pagoda, a small torii (gate), bridges, and a Japanese teahouse. The 24-acre (97,700 m2) park lies in southeast Hilo on the "Big Island" of Hawai'i.

✉ **Addr:**	189 Lihiwai St, Hilo HI 96720	♀ **Where:**	19.7264867 -155.0684827	
❓ **What:**	Park	◐ **When:**	Afternoon	
👁 **Look:**	North-northeast	W **Wik:**	Lili'uokalani_Park_and_Gardens	

'Akaka Falls is a 442 feet (135 m) tall waterfall, viewable from a mostly flat paved trail in 'Akaka Falls State Park. The loop trail is about 1/2 mile (900 m) long and includes a view of the less impressive Kahūnā Falls downstream. The park [paid parking] is about 11 miles (18 km) north of Hilo.

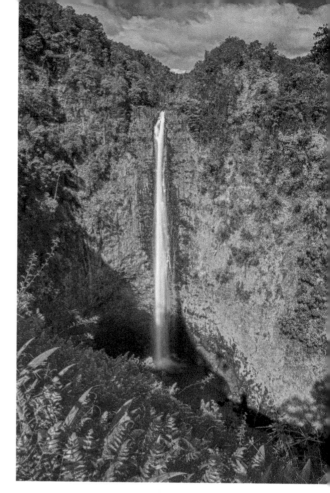

Addr:	'Akaka Falls Rd, Honomu HI 96728	Where:	19.8538739 -155.1541328
What:	Waterfall	When:	Morning
Look:	West-southwest	Wik:	'Akaka_Falls_State_Park

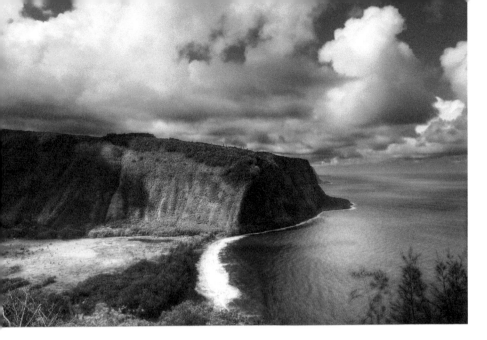

Waipiʻo Valley Lookout is a splendid view from almost 2,000 feet (610 m) above the ancient capital of Hawaiʻi. There is a parking lot and a concrete viewing platform at the end of Honokaʻa-Waipiʻo Road (HI-240), 8 miles (13 km) west of Honokaʻa and 50 miles (80 km) northwest of Hilo.

The road into the valley is the steepest road of its length in the United States, dropping 800 vertical feet (244 m) in 0.6 miles (0.9 km) at a 25% average grade. It is only open to four-wheel-drive vehicles.

The valley was the site of the final scene in the 1995 sci-fi film *Waterworld*, at which (spoiler alert) the main characters found dry land.

✉ **Addr:**	Honokaʻa-Waipiʻo Road, Honokaʻa HI 96727	♀ **Where:**	20.11792 -155.584313
❷ **What:**	Lookout	☽ **When:**	Morning
👁 **Look:**	West-northwest	Ⓦ **Wik:**	Waipiʻo_Valley

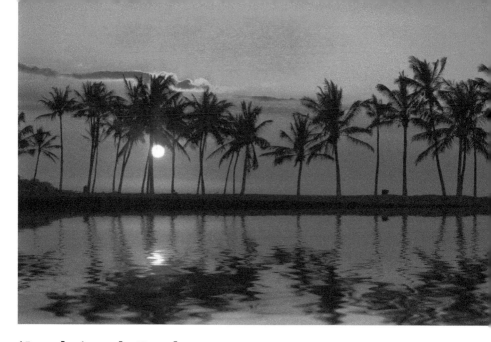

'Anaeho'omalu Beach is the best place to photograph the sunset on the island of Hawai'i. The beach faces west-northwest to the setting summer sun and has a row of palm trees for a silhouette foreground, plus a reflecting pool (Ku'uali'i Fishpond).

The beach is 70 miles west of Hilo, by Waikōloa Beach Marriott Resort, south of Hilton Waikōloa Village.

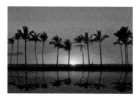

✉ **Addr:**	Waikōloa Rd, Waikōloa HI 96738	♀ **Where:**	19.914632 -155.886286
❓ **What:**	Beach	◐ **When:**	Morning
👁 **Look:**	West	↔ **Far:**	100 m (330 feet)

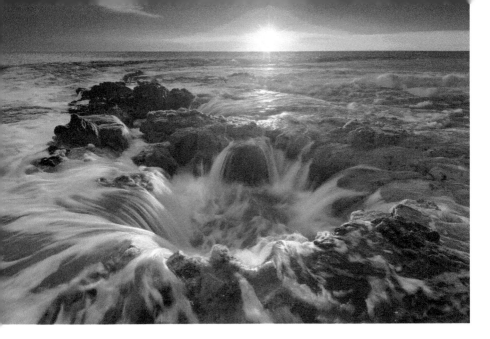

Pele's Well is a pair of vertical lava tubes in the ocean, about 10 feet (3 m) deep, with a tunnel to the ocean. When a wave comes in, water shoots through the tunnel and overflows out. As the water recedes back in, the ocean flows into the well, and you can take a magical photo.

The well is named for the Hawaiian goddess of volcanoes and fire and the creator of the Hawaiian Islands.

Pele's Well is easily reached by walking about 1/2 mile (800 m) south of the parking lot at Wawaloli Beach, off Makako Bay Drive, south of Kona Airport, 1.2 miles west of the HI-19 road. As with all lava ocean features, this is a dangerous area so watch for slippery rocks and rogue waves. For a romantic sunset shot, you'll need a tripod and a slow shutter speed, around 1/8s.

✉ **Addr:**	Makako Bay Dr, Kailua HI 96740	♀ **Where:**	19.710546 -156.049317
❓ **What:**	Well	☽ **When:**	Sunset
👁 **Look:**	West-southwest	↔ **Far:**	27 m (89 feet)

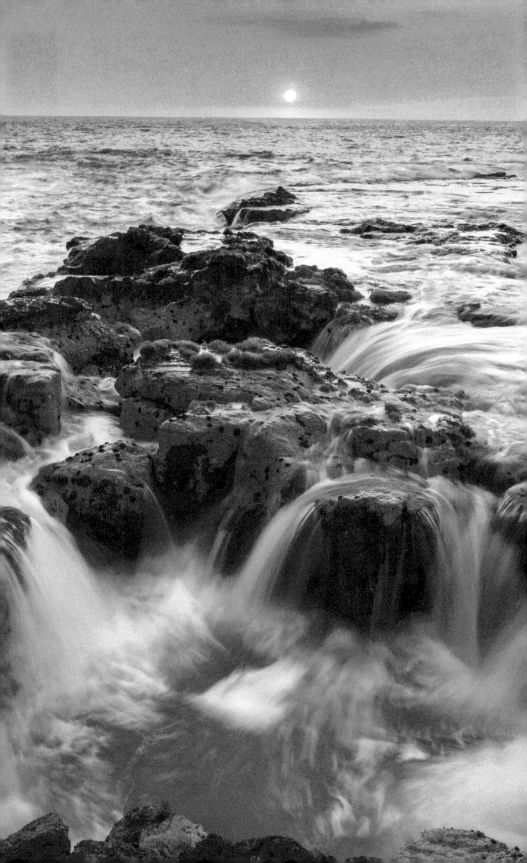

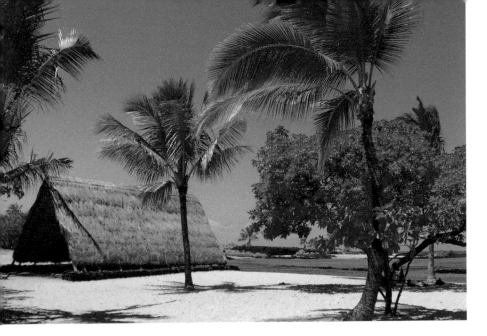

Honokōhau Hālau is a reconstructed Hawaiian school, a thatched shelter on a beach in Kaloko-Honokōhau National Historical Park. The school is by ʻAiʻopio Fishtrap, a 1.7-acre (0.69 ha) pond with a stone wall with small openings, where fish could enter from the sea when small, but were trapped and easily caught as needed.

From HI-19, drive west about 2/3 mile on Kealakehe Parkway, then hike about 1,100 feet (330 m) to Honokokohau Harbor.

✉ **Addr:**	Ala Mauka-Makai, Kailua-Kona HI 96740	♀ **Where:**	19.6714517 -156.0258201	
❓ **What:**	School	☽ **When:**	Morning	
👁 **Look:**	South-southwest	W **Wik:**	Honokōhau_Settlement_and_Kaloko-Honokōhau_National_Historical_Park	

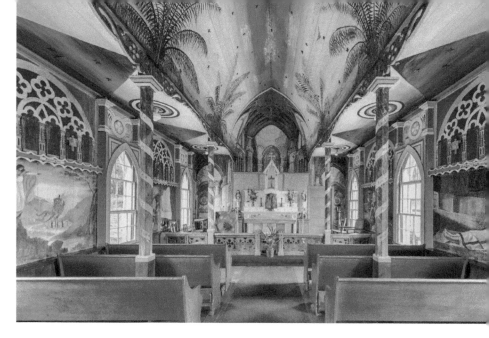

St. Benedict Painted Church is known as "The Painted Church" for its colorful interior frescoes. This small church was built and painted between 1899-1902 by Belgian Catholic missionary Father John Velghe. Various biblical scenes depict Cain's murder of Abel, Jesus refusing the Devil, and sinners in Hell.

A trompe l'oeil behind the altar gives the impression of Gothic vaults, making the small church look like a European Gothic cathedral.

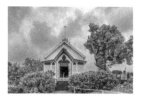

✉ **Addr:**	84-5140 Painted Church Rd, Captain Cook HI 96704	♀ **Where:**	19.435049 -155.888371	
❓ **What:**	Church	◑ **When:**	Anytime	
👁 **Look:**	East	W **Wik:**	St._Benedict%27s_Catholic_Church_(Hōnaunau,_Hawaiʻi)	

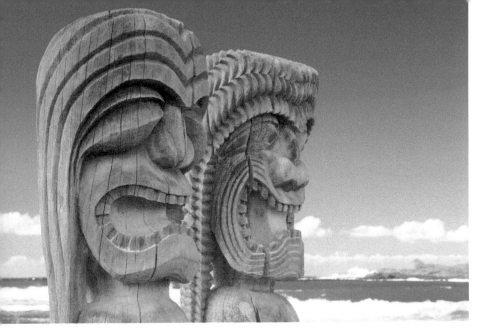

Puʻuhonua o Hōnaunau National Historical Park is an ancient refuge for criminals and defeated warriors. The cove area of the park has protector *kiʻi* (statues, above) and a reconstructed temple (below). From HI-11 at Keokea, drive west 4 miles (6 km) on Keala O Keawe Rd to the park's entrance, then walk 330 feet (100 m) to the cove.

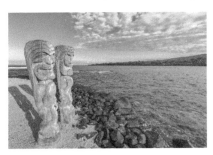
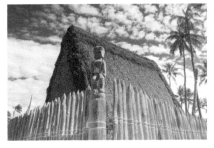

✉ **Addr:**	State Hwy 160, Hōnaunau HI 96726	⚲ **Where:**	19.421706 -155.912038	
❓ **What:**	National historical park	◐ **When:**	Anytime	
👁 **Look:**	Southwest	Ⓦ **Wik:**	Puʻuhonua_o_Hōnaunau_National_Historical_Park	

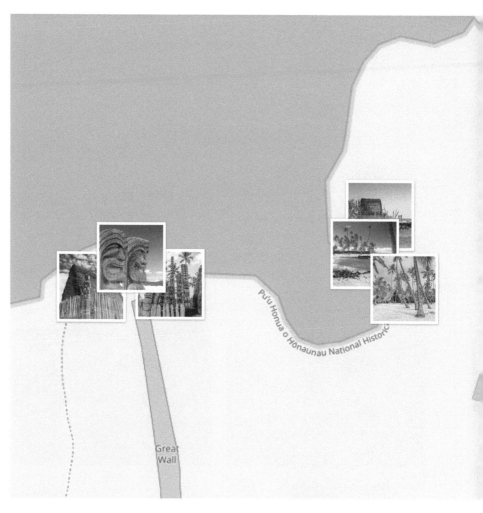

Great
Wall

Pu'u Honua o Hōnaunau National Historic

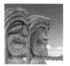

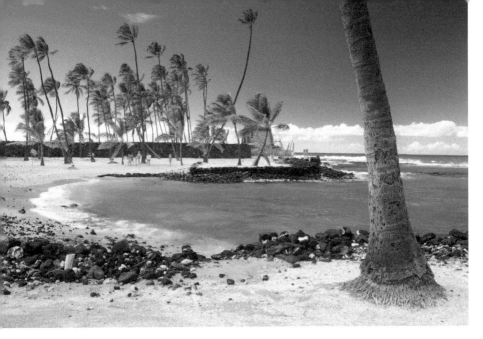

Above: The cove and reconstructed Hale o Keawe temple (in the distance).

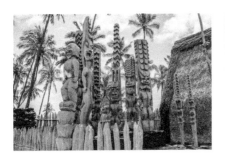

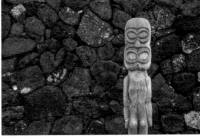

Below: Hawaiian hale (house).

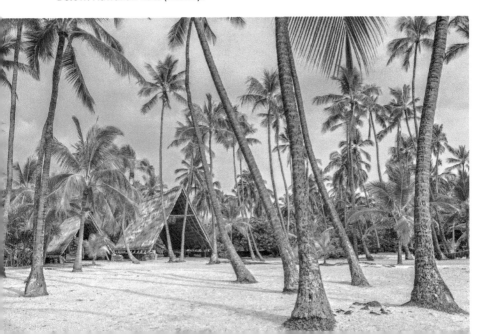

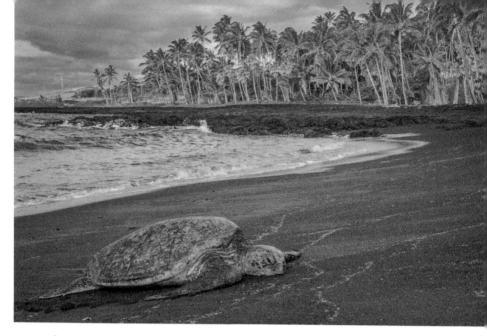

Punalu'u Beach is a black sand beach, where lava flowing to the ocean cooled and exploded into small pebbles. Green turtles bask on the sand, and spinner dolphins and humpback whales can be sighted offshore. Punalu'u Beach is between Nā'ālehu and Pāhala, about a mile (1.6 km) south of the highway.

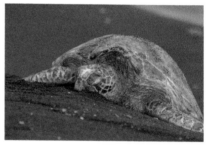

✉ **Addr:**	Ninole Loop Rd, Nā'ālehu HI 96772	♀ **Where:**	19.135793 -155.504351
❷ **What:**	Beach	☾ **When:**	Morning
👁 **Look:**	Southwest	Ⓦ **Wik:**	Punalu'u_Beach

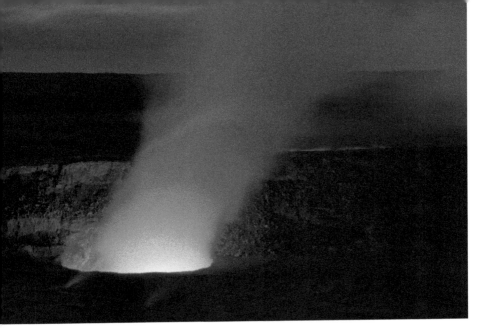

Kīlauea is the most active volcano in Hawai'i. The last eruption in 2018 destroyed two towns and extended new land nearly a mile into the sea. Located along the south-east shore of the island in Hawai'i Volcanoes National Park, the volcano can be seen from a road around the crater, along with dried lava from recent flows.

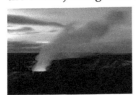

Since this is an active volcano, conditions can change. At the time of publication, Kīlauea could be visited at it was not erupting, and no molten lava was visible in or out of the park.

For current information, visit https://www.nps.gov/havo/planyourvisit/lava2.htm.

✉ **Addr:**	Crater Rim Drive, Hawai'i Volcanoes NP HI 96718	♀ **Where:**	19.4196821 -155.2878744
❓ **What:**	Lava	◑ **When:**	Anytime
👁 **Look:**	South-southeast	W **Wik:**	Kīlauea

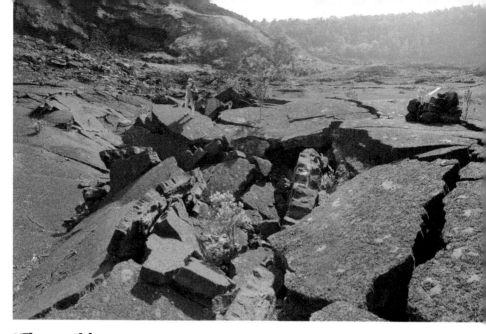

Kīlauea Iki is a pit crater that is next to the main summit caldera of Kīlauea. You can hike across the floor of the crater, which was a lake of lava in 1959. From the Visitor Center, hike Crater Rim Trail (below left) for about 1.6 miles (2.5 km). Nearby is the more accessible Devastation Trail (below right), a half-mile path from a parking lot.

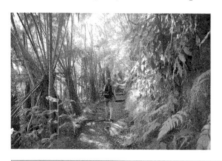

✉ **Addr:**	Kīlauea Iki Trail, Hawai'i Volcanoes NP HI 96718	♀ **Where:**	19.414736 -155.2516693
❓ **What:**	Pit crater	☽ **When:**	Morning
👁 **Look:**	West	Ⓦ **Wik:**	Kīlauea_Iki

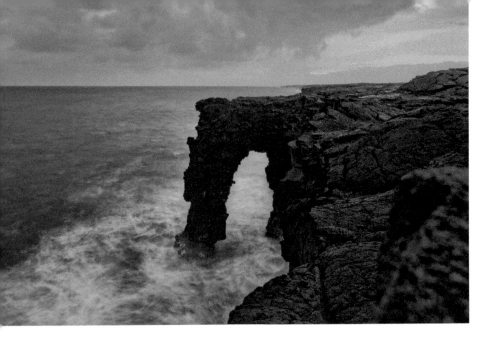

Hālei Sea Arch is a 90-foot-high (27 m) natural arch, created by the ocean eroding a lava cliff. To reach here, drive about 20 miles (31 km) south of Kīlauea on Chain of Craters Road, then walk about 250 feet (80 m) to the coast.

From this point, the road is closed to vehicles but you can walk east through the other-worldly landscape of a dried lava field.

✉ **Addr:**	Chain of Craters Rd, Pāhoa HI 96778	♀ **Where:**	19.294747 -155.097626
❷ **What:**	Natural arch	☾ **When:**	Morning
👁 **Look:**	Southwest	W **Wik:**	Hālei_Sea_Arch

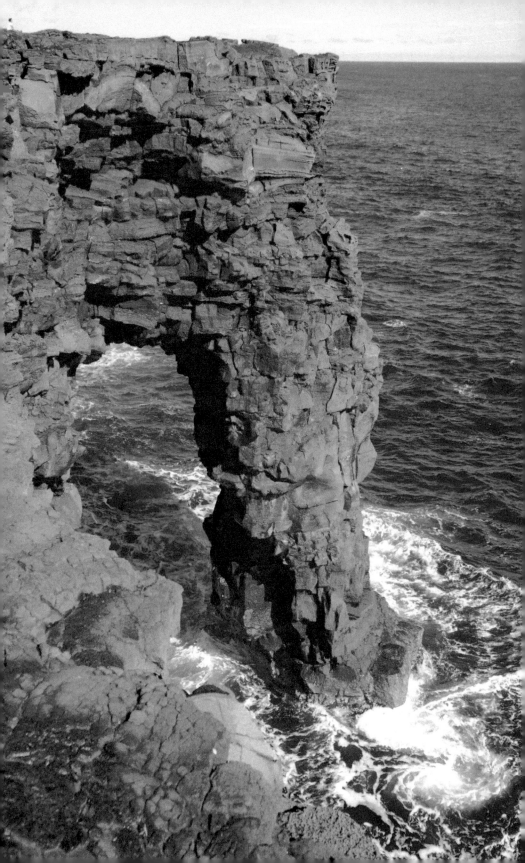

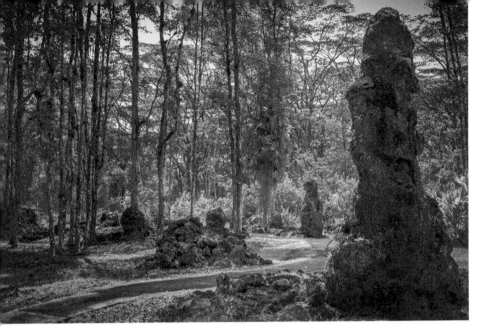

Lava Tree State Monument is a forest of lava trees along an 0.7 mile (1.1 km) loop trail. This unusual volcanic feature is the result of a lava flow that swept through a forested area and left behind lava molds of the tree trunks.

The park is 3.6 miles (6 km) southeast of Pāhoa.

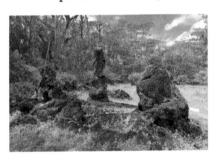
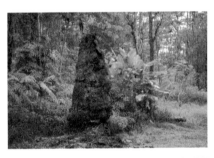

✉ **Addr:**	HI-132, Pāhoa HI 96778	📍 **Where:**	19.483239 -154.902155	
❓ **What:**	State monument	☽ **When:**	Anytime	
👁 **Look:**	North-northwest	Ⓦ **Wik:**	Lava_Tree_State_Monument	

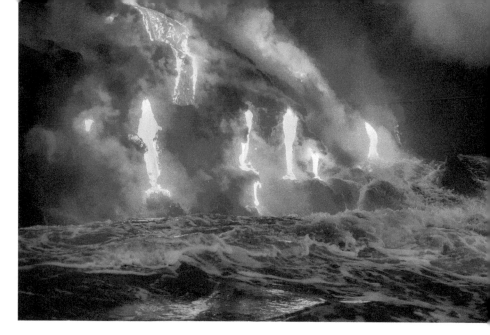

Lava in the ocean is a good name for a band but unfortunately is not occurring as of publication time. However, the active volcanoes of Hawai'i can change at any moment and the formation of future parts of the Big Island is a good way to end our photo tour of Hawai'i.

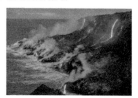

✉ **Addr:**	Hawai'i Volcanoes NP, Hawai'i HI 96718	♀ **Where:**	19.356508 -154.968209
❓ **What:**	Lava	☾ **When:**	Anytime
👁 **Look:**	Southwest	↔ **Far:**	140 m (450 feet)

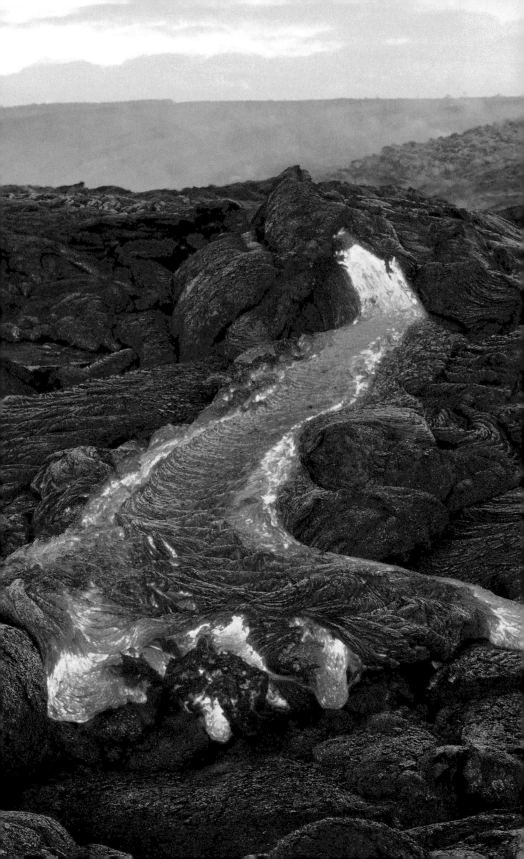

Credits

Thank you to the many wonderful people and companies that made their work available to use in this guide.

Photo key: The number is the page number. The letters reference the position on the page, the distributor and the license. Key: a:CC-BY-SA; b:bottom; c:center; d:CC-BY-ND; f:Flickr; h:Shutterstock standard license; l:public domain; s:Shutterstock; t:top; w:Wikipedia; y:CC-BY.

Cover image by Shane Myers Photography/Shutterstock. Back cover image by Shaun Jeffers/Shutterstock. Other images by: 7maru (22t, 23 fy); Alicia0928 (45 sh); Tomas Del Amo (21t, 21c sh); Mh Anderson (111t sh); Andysartworks (153 sh); Artyooran (39t, 86 sh); Paul Atkinson (24 fy); Tinou Bao (39b sh); Yvonne Baur (169 sh); Stanislav Beloglazov (88t sh); Louise E Bensvik (86 fy); Paul Bica (154t sh); Jay Bo (83t sh); Ralf Broskvar (168 sh); George Burba (160t, 160, 162t fy); Colin Capelle (56t sh); Yi-chen Chiang (43t sh); Kelvin Chico (86 sh); Robert Cicchetti (164t, 164 sh); Chase Clausen (132t sh); Cleanfotos (47, 50t sh); Paula Cobleigh (103 sh); Curtis (162 wa); Daderot (146t, 146 fy); Daveynin (165 sh); Dawnpatrol85 (34 sh); Vito Defilippo (27b sh); Alexander Demyanenko (108, 163 sh); Dlabajdesign (40 sh); Donland (109, 136t, 137 sh); Angela Dowin (114t fy); Dronepicr (97t, 97, 128 sh); Dshumny (60t sh); Emperorcosar (36c, 37, 56b, 150t sh); Eqroy (30, 114, 116, 116 sh); Phillip B. Espinasse (45b, 67, 89, 91 sh); Marisa Estivill (104t sh); Bill Florence (135 sh); Follow2find (50b sh); Fominayaphoto (122, 141t, 160 sh); Caleb Foster (134 sh); Allen G (17b, 34t, 46t, 169t sh); Eddy Galeotti (25, 28t fy); Edmund Garman (60 sh); Agnieszka Gaul (166t sh); Gennadiyp (63 sh); Gg-foto (31, 130t, 130 sh); Jose Gil (79 sh); Gary Gilardi (158 sh); Michael Gordon (28 sh); Rocky Grimes (104c sh); Kelly Headrick (80 sh); Steve Heap (106, 132, 132 sh); Michael Hillman (80 sh); Chris Howey (116t sh); Idreamphoto (133t sh); Photo Image (98, 98, 117 sh); Instacruising (69t sh); Ivan_sabo (119 sh); Izo (19 sh); Malachi Jacobs (46 sh); Jeff W. Jarrett (63t sh); Shaun Jeffers (43, 45t sh); Juancat (57t sh); Karamysh (24 fd); Dru Kelly (128 sh); James Kirkikis (54, 77 sh); Klarka0608 (59t sh); Byungsuk Ko (77t sh); Luc Kohnen (146 sh); Deborah Kolb (33b, 67b sh); Zoia Kostina (59 wy); Frank Kovalchek (167 sh); Ingus Kruklitis (24t sh); Surat Kulapatana (30t sh); Kuma (163 sh); Pierre Leclerc (111b, 112, 120t, 128t, 132 sh); Radoslaw Lecyk (152 sh); Ralf Lehmann (170 sh); Malgorzata Litkowska (75t sh); David Litman (162 sh); Gang Liu (48t sh); Jamison Logan (54 sh); Dale Lookholder (149 fy); Lori (83 sh); Lucas_moore (113 sh); Martin M303 (94t fy); Patrick Malone (74 fa); Jai Mansson (77 sh); Maridav (66t, 117t, 122 sh); Benny Marty (14t, 21, 21b, 34, 36t, 36b, 37, 88, 88, 88b, 92t sh); Color Me Maui (98, 112 fy); Colleen Mcneil (166 sh); Leigh Anne Meeks (52t, 59, 65t, 77b, 100b fa); John Menard (158t sh); Dudarev Mikhail (80t sh); Mnstudio (96t, 101, 101, 104b, 118t, 150, 165t, 165, 168 fy); Mojo-jo-jo (86t sh); Eduard Moldoveanu (168t sh); Jennifer Larsen Morrow (147 sh); Luciano Mortula (74b sh); Victor Moussa (17 sh); Shane Myers (57, 62b, 67t, 70t, 70, 74t, 77, 83, 83b, 84, 85, 98t, 112t, 121, 163t sh); Nagel Photography (51t, 51 sh); Andre Nantel (92 sh); Nekod (40t sh); Nekomamire (66 sh); Felix Nendzig (141 sh); Roger Nichol (153t sh); Nimon (89 wl); Michael de Nyse (134t sh); Joseph O (93 fy); Justin de La Ornellas (65b sh); Orxy (156t sh); Osugi (24, 24 sh); Ami Parikh (54t sh); Ron Paul (151 sh); Marek Pelikan (124 sh); Mr.popz Photo (40 sh); Ventu Photo (136, 140b sh); Leah Pirone (17 sh); Brian Pirwin (53t sh); Susanne Pommer (65c, 143b, 162b sh); Bob Pool (139 sh); Marek Poplawski (108t, 159t, 159 fy); Prayitno (75 sh); Pung (89t fy); Daniel Ramirez (40, 41, 50, 78t, 78 sh); Alex Roch (86 sh); Ruglig (73t sh); Robin Runck (101t sh); Dmitrii Sakharov (71t, 74, 84 fd); Ben Schmitt (126t sh); Schoukse (106t sh); Mohamed Selim (122t sh); Francois Seuret (143t sh); Ajay Simha (157 sh); David P. Smith (136 sh); Rs Smith (105 sh); Jo Ann Snover (59b sh); Kenneth Sponsler (145 wl); Bernard Spragg (69 sh); Adam Springer (95, 128b, 129 sh); Jeff Stamer (131, 155 sh); Chris Steffens (37t sh); Hotaik Sung (114 sh); Elena

Suvorova (67c sh); Svetlanasf (84t fy); Alice Taiwan (86 sh); Christophe Testi (116b wa); Theskuj (100c sh); World Traveller (134 wa); Victor-ny (89 sh); Vladimir3d (133 wa); Cristo Vlahos (73b sh); Vlue (107 fy); John Voo (66 sh); Abbie Warnock-matthews (125t, 136, 140t, 144t, 145t sh); Jeff Whyte (17t, 17, 17, 27t, 29, 33t sh); Wildnerdpix (141 fy); Jim Winstead (149t sh); Worldstock (152t fd); Steven Worster (81t wa); Wppilot (15 sh); Xaoc (155t sh); Christopher Yasuma (50 sh); Lynn Yeh (18t sh); Zerothesignal (100t sh); Youli Zhao (62t, 118 sh).

Some text adapted from Wikipedia and its contributors, used and modified under Creative Commons Attribution-ShareAlike (CC-BY-SA) license. Map data from OpenStreetMap and its contributors, used under the Open Data Commons Open Database License (ODbL).

For corrections and improvements, thank you to Donna Coleman for her enthusiasm and ideas about Kaua'i.

This book would not exist without the love and contribution of my wonderful wife, Jennie. Thank you for all your ideas, support and sacrifice to make this a reality. Hello to our terrific kids, Redford and Roxy.

Thanks to the many people who have helped PhotoSecrets along the way, including: Bob Krist, who answered a cold call and wrote the perfect foreword before, with his wife Peggy, becoming good friends; Barry Kohn, my tax accountant; SM Jang and Jay Koo at Doosan, my first printer; Greg Lee at Imago, printer of my coffe-table books; contributors to PHP, WordPress and Stack Exchange; mentors at SCORE San Diego; Janara Bahramzi at USE Credit Union; my bruver Pat and his family Emily, Logan, Jake and Cerys in St. Austell, Cornwall; family and friends in Redditch, Cornwall, Oxford, Bristol, Coventry, Manchester, London, Philadelphia and San Diego.

Thanks to everyone at distributor National Book Network (NBN) for always being enthusiastic, encouraging and professional, including: Jed Lyons, Jason Brockwell, Kalen Landow (marketing guru), Spencer Gale (sales king), Vicki Funk, Karen Mattscheck, Kathy Stine, Mary Lou Black, Omuni Barnes, Ed Lyons, Sheila Burnett, Max Phelps, Jeremy Ghoslin and Les Petriw. A special remembrance thanks to Miriam Bass who took the time to visit and sign me to NBN mainly on belief.

The biggest credit goes to you, the reader. Thank you for (hopefully) buying this book and allowing me to do this fun work. I hope you take lots of great photos!

© Copyright

PhotoSecrets Hawai'i, first published August 15, 2019. This version output June 15, 2019.

ISBN: 978-1930495395. Distributed by National Book Network. To order, call 800-462-6420 or email customercare@nbnbooks.com.

> *"And what is the use of a book,' thought Alice*
> *'without pictures or conversations?'"*
> — *Alice's Adventures in Wonderland, Lewis Carroll*

© Copyright

⚓ Disclaimer

The information provided within this book is for general informational purposes only. Some information may be inadvertently incorrect, or may be incorrect in the source material, or may have changed since publication, this includes GPS coordinates, addresses, descriptions and photo credits. Use with caution. Do not photograph from roads or other dangerous places or when trespassing, even if GPS coordinates and/or maps indicate so; beware of moving vehicles; obey laws. There are no representations about the completeness or accuracy of any information contained herein. Any use of this book is at your own risk. Enjoy!

✉ Contact

For corrections, please send an email to andrew@photosecrets.com. Instagram: photosecretsguides; Web: www.photosecrets.com

▗▖ Index

Welcome

By Andrew Hudson

THANK YOU for reading PhotoSecrets. I like to start books by flicking from the back cover, so this is a good place for a welcome message.

As a fellow fan of travelling with a camera, I hope this guide will quickly get you to the best spots so you can take postcard-perfect pictures.

PhotoSecrets shows you all the best sights. Look through, see the classic shots, and use them as a departure point for your own creations. Get ideas for composition and interesting viewpoints. See what piques your interest. Know what to shoot, why it's interesting, where to stand, when to go, and how to get great photos.

Now you can spend less time researching and more time photographing.

The idea for PhotoSecrets came during a trip to Thailand, when I tried to find the exotic beach used in the James Bond movie *The Man with the Golden Gun*. None of the guidebooks I had showed the beach, so I thought a guidebook of postcard photos would be useful. Twenty-plus years later, you have this guide, and I hope you find it useful.

Take lots of photos!

Andrew Hudson

Andrew Hudson started PhotoSecrets in 1995 and has published 23 nationally-distributed color photography books. His first book won the Benjamin Franklin Award for Best First Book and his second won the Grand Prize in the National Self-Published Book Awards.

Andrew has photographed assignments for *Macy's, Men's Health* and *Seventeen*, and was a location scout for *Nikon*. His photos and articles have appeared in *National Geographic Traveler, Alaska Airlines, Shutterbug, Where Magazine,* and *Woman's World*.

Born in England, Andrew has a degree in Computer Engineering from the University of Manchester and was previously a telecom and videoconferencing engineer. Andrew and his wife Jennie live with their two kids and two chocolate Labs in San Diego, California.